# A baking cookbook you need Every Day

**Everyday cookbook series., Volume 4**

Maleb Braine

Published by Maleb Braine, 2022.

While every precaution has been taken in the preparation of this book, the publisher assumes no responsibility for errors or omissions, or for damages resulting from the use of the information contained herein.

A BAKING COOKBOOK YOU NEED EVERY DAY

**First edition. September 27, 2022.**

Copyright © 2022 Maleb Braine.

ISBN: 978-1915666086

Written by Maleb Braine.

# Also by Maleb Braine

**Everyday cookbook series.**
French cookbook for everyday use.
Italian Cookbook for everyday use.
Bread baking cookbook you need every day
A baking cookbook you need Every Day

# Book Description

Whether you are an experienced baker or this is your first time in the kitchen, this recipe book is for you. These recipes are family cultivated, perfectly crafted for stay-at-home moms who yearn to provide delicious treats and happy memories for their children. Everyone loves homemade baked goods: they're the perfect symbol of love. The more information at your disposal, the more scrumptious desserts you'll be able to create. From stunning your family, impressing your kids' classmates at the bake sale, or just whipping yourself up a comforting treat, the blessings of baking are endless. Nothing is more gratifying than creating something from nothing—making something with your own two hands. This recipe book has been carefully crafted from recipes that date back generations, recipes that have been perfected and passed down; and now, in your lap, you are free to imitate or elevate these dishes. If you're afraid you don't have enough experience, worry not. Experience can only come by trying. So get in the kitchen, preheat your oven, and just wait to see what you can create!

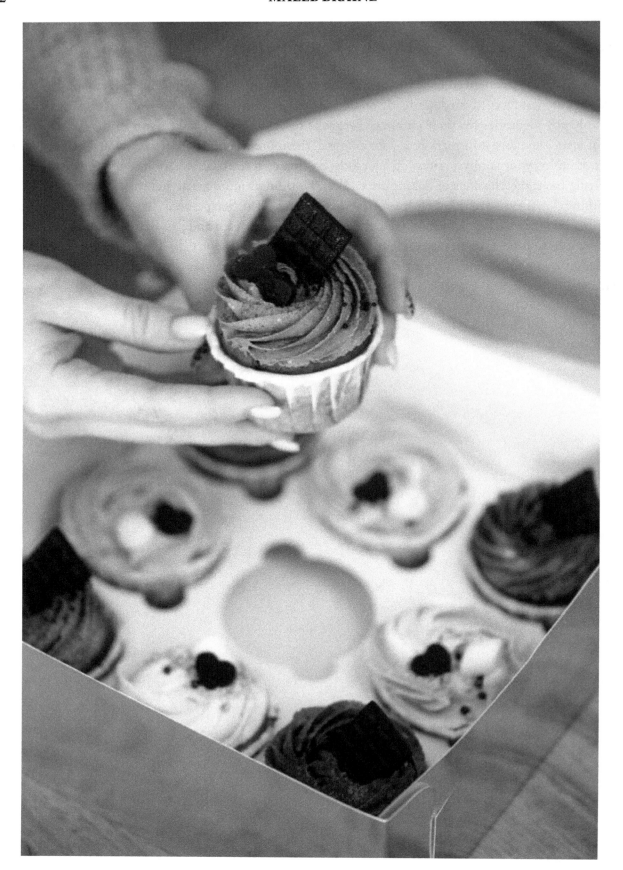

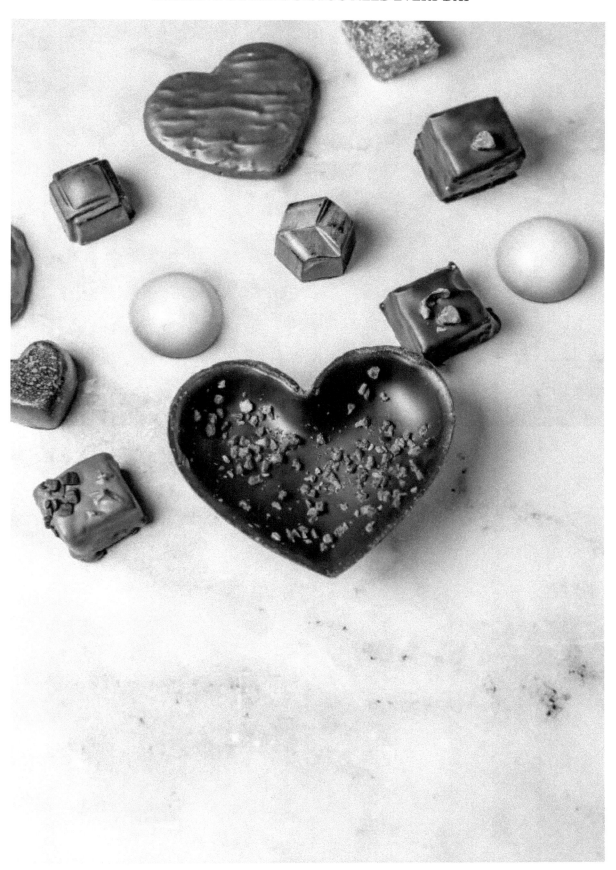

# Baking cookbook you need Every Day

*Easy to follow recipes and techniques to make Delicious decorated cakes, classic cookies, comforting treats, biscuits, pies and more.*

## Maleb Braine

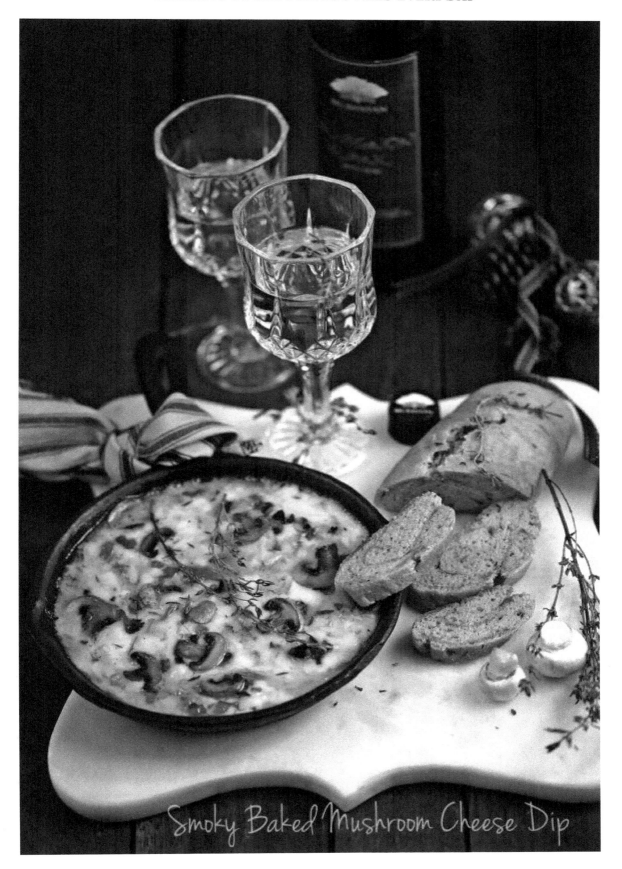
Smoky Baked Mushroom Cheese Dip

## © Copyright 2022 - All rights reserved.

The content contained within this book may not be reproduced, duplicated or transmitted without direct written permission from the author or the publisher.

Under no circumstances will any blame or legal responsibility be held against the publisher, or author, for any damages, reparation, or monetary loss due to the information contained within this book, either directly or indirectly.

<u>Legal Notice:</u>

This book is copyright protected. It is only for personal use. You cannot amend, distribute, sell, use, quote or paraphrase any part, or the content within this book, without the consent of the author or publisher.

<u>Disclaimer Notice:</u>

Please note the information contained within this document is for educational and entertainment purposes only. All effort has been executed to present accurate, up to date, reliable, complete information. No warranties of any kind are declared or implied. Readers acknowledge that the author is not engaged in the rendering of legal, financial, medical, or professional advice. The content within this book has been derived from various sources. Please consult a licensed professional before attempting any techniques outlined in this book.

By reading this document, the reader agrees that under no circumstances is the author responsible for any losses, direct or indirect, that are incurred as a result of the use of the information contained within this document, including, but not limited to, errors, omissions, or inaccuracies.

# Introduction

*Baking is done out of love, to share with family and friends, to see them smile.*
–Anna Olsen

With a role model in the kitchen, young minds can grow to learn valuable skills that will influence the rest of their lives. Mothers are the first asset that a child has at their disposal to teach them how to nourish their minds and bodies. However, modern, fast-paced lifestyles threaten the peace that can be found in baking. Baking and cooking takes patience, dedication, and an underlying love for the people in your life. Work, the constant care that it takes to raise a child, relationships, and the stresses of day-to-day life can make it difficult to get in the kitchen, but it's not impossible.

85% of millennial working mothers don't regularly cook at home. However, when they did, the data proves that they made sure to eat foods that are nutritious, and foods that will keep themselves and their families healthy and happy. Imagine the systematic good that could come if the 85% had an easily accessible cache of recipes to guide them back to their roots, making it easier than ever to use their two hands to create.

# The Importance of Home Baking

The best part about baking is that it can directly combat the pressure of living and become a remedy to everyday anxieties. Endless comfort awaits; from nostalgic smells to pleasant tastes and sensory gratification, along with the satisfaction of making something from nothing—those are just two reasons as to why you should start baking. Here are some more:

The kitchen is a space where you are in control. You are responsible for measuring correctly, which is painless when the amounts are laid out before you; but you are also in control of your imagination, which can shine through baked goods. The rhythm and flow of baking can get you in the zone, where the rest of the world fades away and you can channel your inner creativity by hand-picking the flavors you'd like to focus on or decorating with a hidden artistic flair.

If you're looking to outsource artistic flair, turn to your kids! Learning to bake is a valuable skill that children will take into every phase of their life. Not only do they get to stretch their brain with tricky mathematical measurements and the possibility of a failed experimental souffle, you also get to spend quality time with them in the home where they feel safe and can open up to you about anything. Frustrations from accidentally leaving out the eggs can be an opportunity to teach about the frustrations of life, and making the next batch will teach them to never give up. Besides, the reinforcement of a delicious treat at the end of the process will be reason enough for them to stay engrossed in the activity.

This is not to say that baking can only be used as an educational tool for your children. Solo bakes can be especially therapeutic, a time to reflect or focus or just distract yourself from the stress of the day. When baking is used as a therapy, you can use your products as a corporeal presentation of your emotions, giving them as a gift of love to the people who it's hardest to say the right words to. Putting time and effort into a gift for someone else to enjoy is a universal message: "I'm thinking about you." Sometimes, that's all that they—and you—need to hear, because when they bite into that perfect cookie, they'll be thinking about you too.

# A Lifelong Story

Having raised five children myself, I understand the hardship of balancing our lives and our diets, and how sometimes I felt like cooking for them took away from the little time I had at home. As my kids grew, it was hard to stay connected to them. I felt like I wasn't doing a good enough job as a mom.

It was at this point that I decided to flip the narrative, and so I dug out my grandmother's old recipe book. Though I felt my skills were rusty, I leaned into my enthusiasm and began to perfect each one. My excitement about the project piqued the interest of my kids, and they slowly ended up by my side. This process was the perfect opportunity to engage my family in a generational pursuit of deliciousness.

For over a decade now, I've been doing better at helping my kids make memories with me and giving them a taste of the comforts I experienced as a child by my mother and grandmother's side. My kids are growing into well-rounded, happy, and healthy people, and I'm so grateful to have been able to share this passion with them.

However, I know that not everyone is as lucky by default. A mother's support system can make or break her mental health. Sometimes it can look like a spouse, or a mother or aunt, but some mothers are on their own. Not everyone is as fortunate as I was to have a matron who can pass their knowledge down to them, and that was the catalyst for me publishing this book. I wanted to share my wealth of recipes to those who needed them, to the women who didn't have anyone to teach them, or who don't feel like they have the time or energy to consistently make recipes at home or from scratch.

Even celebrities, with endless events and foreign hotel rooms, find solace in baking. Taylor Swift, for example, recently named Female Artist of the Decade, is famous for presenting baked goods to her friends and making peace with enemies through a platter of cookies. Think about how famous you'll be to the other moms at the bake sale when you arrive with a slew of expertly-crafted desserts. Not to mention, your kids or partner will revere you as a celebrity in your house every day.

Though it might seem challenging to take the leap, I promise that the perks of baking at home will be immeasurable.

# Chapter 1:

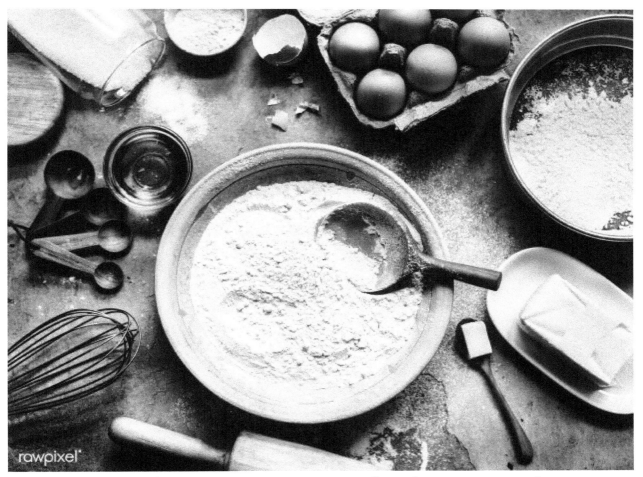

# Ingredients, Equipment and Other Essentials

Where there's a whisk, there's a way!

When I first began my baking journey, I felt helpless as to where to start. None of my tools seemed to do what I wanted, and I spent too much unnecessary money on equipment I never ended up using. When starting out, it's best to go back to basics.

Though some machines are helpful, they're usually not necessary. Some specialty pans are fun, but if you're cramped for space, stick with the recipes that can be made in the more standard-shaped tins.

Organization is key. Finding baking tins that can stack neatly together will be really nice for storage purposes, as well as pots and pans. As for your pantry, try to keep the essentials right up at the front for easy access.

# Basic Equipment List

# Measuring cups

The key to executing recipes correctly is measuring correctly, and having a trusty set of measuring cups will make that happen easily. There are two types of measuring cups you should have: one set for wet ingredients and one for dry. Now, both types do technically measure the correct volume, but in practice, you're less likely to make mistakes like spilling or measuring incorrectly when you use the cup that's meant for the ingredient you're using. Dry measuring cups usually measure up to one cup (with separate cups or markings for ½ cup, ⅓ cup, ¼ cup, etc), and generally have a flat lip, so leveling off flours is a breeze. Wet measuring cups are usually much larger, some able to measure up to 8 cups, which can be very useful when making a big batch. It would be a total hassle to try and transfer 8 individual cups of fickle liquid without spilling, which is why a special wet measuring cup is worth it. Wet measuring cups also usually have a large mouth and sometimes a spout for easy pouring, and are definitely worth the money.

Measuring spoons are equally as important, because even a little too much baking powder can be disastrous. Try to find ones with flat, wide, brims, for easy leveling.

# Wooden spoons

There's nothing more nostalgic than a classy wooden spoon stirring a simmering pot. These long-lasting utensils have been wielded by grandmothers for hundreds of years and for good reason. They're resilient, multi-purpose, and a must-have for your kitchen. Just make sure to wash them the way grandma did—by hand—otherwise they could crack in the dishwasher.

# Rubber spatula

This is the chic cousin to the wooden spoon: the rubber spatula is modern, sleek, and anti-waste. What's more satisfying than scraping out every last drop of cake batter? Waste not, want not. Need to finesse a french dessert? These are expertly crafted for folding, so your egg whites will never deflate.

# Spatula/Metal turner

Delicate, hot desserts often need a little support, and a thin metal spatula can provide just that. For serving and transferring, you will reach for this tool all the time.

# Pastry brush

Though this might seem like a luxury for seasoned bakers, the pastry brush can actually be used for more practical tasks, like greasing the hard-to-reach corners of a baking pan and making sure that your cupcakes don't lose their perfect shape. Pastry brushes are also ideal for applying egg wash (which will make your pies or pastry shine), glazing fruit on top of a cake, or making sure the right amount of butter gets into the crooks of a slice of bread.

# Whisk

Ah, the trusty whisk, your right hand man. Try and find a sturdy one, with thicker tines. Perfect for quickly beating together eggs or wet ingredients, you'll use a manual whisk more than you'll use an electric one.

# Kitchen Scissors

No, you can't just borrow your sewing or hair-cutting scissors; this pair of long, sharp blades needs to be designated for cooking. While obviously made for opening difficult packaging, you can also use them for snipping perfectly sized parchment paper liners, cubing butter, or trimming herbs.

# Rolling Pin

Absolutely necessary for creating thin sheets of pie dough, this trusty fellow can also smash graham crackers or cookies in a gallon sized ziploc if you want to create other types of crusts without a food processor.

# Fine Mesh Sieve

Whether you're straining the seeds out of your homemade raspberry jam or smoothing out a custard or curd, a sieve is necessary. Not to mention sifting flours or dusting powdered sugar over a finished dessert, you'll definitely need this guy.

# Chef's Knife

Large and in charge, a chef's knife will tackle big projects for you. Slicing up large quantities of fruits or vegetables, chopping herbs, and dicing onions or garlic—pretty much any task can be handled by this knife.

# Paring Knife

The younger brother to the chef's knife, this dainty tool will also come in handy for more precise slicing, trimming the edges of tart crust, or slicing vents in a pie crust.

# Rectangular Baking Pan

The standard size for these that you're looking for is 9x13 inches, and either 1 ½ or 2 inches deep. For sheet cakes, cookies, brownies, roasting ingredients in the oven, or anything, really—this is the most versatile baking pan since it's so big, so invest in a high quality, non-stick variety.

# Round Cake Pan

You'll probably want two of these for special occasion layer cakes. They're usually either 8 or 9 inches in diameter, and either will work for most recipes, as long as you have two identical ones.

# Loaf Pan

If you ever want to bake a homemade loaf of bread, a hearty loaf pan will need to be in your cabinet. Find one with tall, deep sides, rather long: the standard is usually 9 x 5 inches or 8 ½ x 4 ½ inches, and 2-3 inches deep.

# Pie Plate

A 9 inch diameter pie plate is all you'll need to make an infinite variety of pies. Glass or nonstick are both fine, and you can decide if you want one with fluted edges for easy crimping, or flat.

# Square Baking Pan

Most square pans are either 8x8 or 9x9 inches, but there are endless varieties, bigger or smaller. Whatever size you want it, buy two, because these trusty guys are just the smaller cousin to the larger baking sheet, and have just as many options. Cobblers, smaller batches, cornbread: the world is your oyster.

# Wire Rack

Cooling and draining are both things that many recipes call for, so if you don't want soggy desserts, investing in a wire rack is crucial. Try to find one that perfectly fits over a 9x13 baking sheet, because then pretty much anything you bake will be able to cool in style.

# Muffin Pan

There are infinite sizes of muffin pans, but I usually stick with a 24 count one so I can make big batches, and since muffins keep for quite a while, they're such an easy snack. If you know you won't be making muffins or cupcakes that often, look for a 16 or 12 count one. Nonstick is best.

# Sheet Pan

Also called a cookie sheet or a baking sheet, these are thin, large sheets that have the optimal heat retention for cookies or macarons. Look for a sheet that's lighter in color, with handles so you can transfer it easily in and out of the oven, but if all four sides of the sheet are raised, then that's a baking pan, and your cookies might not cook properly.

# Hand Mixer/Stand Mixer

Both of these tools will get the job done. You absolutely want at least one of them to cream together butter and sugar, or make whipped cream or meringue. If you try to make these things with just a whisk, you'll perpetually be frustrated and have a tired arm. If you find yourself falling in love with baking and your bank account will allow it, invest in a stand mixer. However, a mechanical, dual whisk hand mixer is perfect too.

# Parchment Paper, Aluminum Foil, and Storage

The handiest of papers, de-molding your desserts will be a breeze—line cake, cookie, or brownie pans (or any dessert whose batter has a tendency to stick). Aluminum foil can prevent burning and is a great tent for treats you want to keep hot once they're out of the oven. I also recommend keeping gallon and sandwich size ziploc bags around for easy storage of ingredients. Tupperware or other air-tight storage containers are also a must.

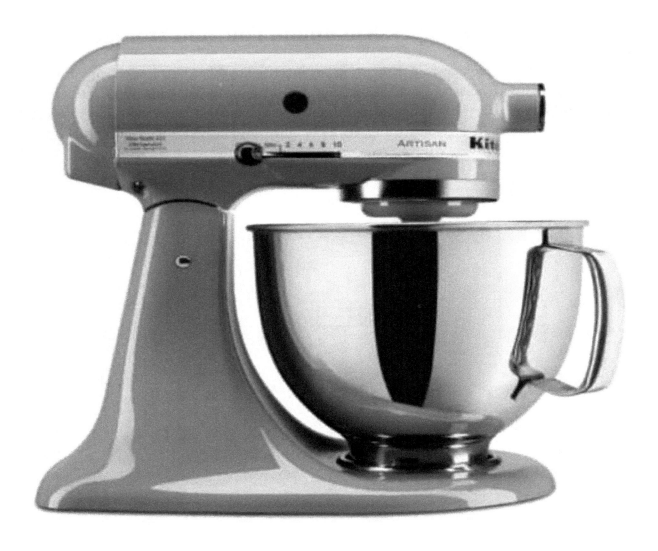

## Store Cupboard Essentials

Once I had gathered the right ingredients and tools, I had no idea where to put it all! I dedicated a cabinet to the project and made sure to organize it in a way that would best serve me, and made sure to keep all my ingredients easily accessible. In the end, the key to baking regularly is having all the ingredients and tools at your disposal. When your essentials are at the front, it's easier to see when they're beginning to run out, so you'll always be prepared.

# Flour

All-purpose flour is the regular, white flour that you're used to. This is the base for most of the recipes here, though there are other types of flour that will be introduced, and knowing the differences between them can help you choose when you're at the store. If you have a gluten intolerance, fear not, because there's tons of high quality brands that make gluten free all-purpose flour. **Whole wheat flour** acts basically the same as all purpose, it just keeps the wheat germ that's removed from AP, so it's more nutritionally fulfilling. **Bread flour** is richer in protein and gluten, and makes for a chewier bite in yeasted breads. **Cake flour** is finer in texture and lower in protein, for fluffier, lighter cakes. **Self raising** or **self rising flour** is white flour with baking soda and salt conveniently already mixed in. There are tons of other flours milled from grains other than wheat, like almond flour, which is naturally gluten free, pistachio flour, coconut flour, etc. Cornstarch is finely milled corn flour and will be used for thickening.

Store flour in an airtight container, preferably large enough to stick an adult hand and measuring cup into. A large, tall plastic container with a lid that clasps is perfect.

The best way that I've found to measure flour consistently is to spoon it into a dry measuring cup and level it off with a butter knife. This ensures the flour is evenly distributed so your recipes will turn out right.

# Leaveners

There are chemical leaveners and biological leaveners. The chemical leaveners are used most in the kitchen because they're fast-acting. The only biological leavener that is used regularly is yeast. **Yeast** is a bacteria that slowly feeds on sugars and produces carbon dioxide that makes loaves of bread rise. Yeast needs ideal temperatures and time to work properly, which is why bread making can take some patience.

The chemical leaveners are probably more familiar to you. **Baking soda** is a leavener that, when paired with acid and heat, produces carbon dioxide. In order for this to work, you need to add an acid to your recipe to activate the alkaline powder. Citrus, vinegar, brown sugar, or any fermented dairy (like yogurt, sour cream, or buttermilk) will work perfectly, and baking the dessert will cause it to rise.

**Baking powder** is just baking soda combined with cream of tartar (an acid) and some cornstarch. This means that you don't need to add any additional acid for it to work.

# Sugar

**White granulated sugar** is the standard, and works in pretty much any recipe as a sweetener. **Brown sugar** is white sugar with added molasses, and **molasses** is a refined syrup that comes from sugar cane and sugar beets. Light or dark brown sugar just depends on the molasses content, and the more molasses, the richer and darker the flavor is. **Powdered sugar**, AKA confectioners sugar, is white sugar that has been processed to be super fine, and whips perfectly in frostings. **Turbinado sugar**, AKA raw sugar, has larger crystal structure and is perfect for decorating pies or pastry for a sweet textural crunch.

Agave, maple syrup, honey, and corn syrup are also all useful sweeteners, and can be used to create deeper flavor profiles.

Store sugars in airtight containers to prevent bugs.

# Salt

**Granulated table salt**, iodized or not, is the stuff that you'll need for most recipes. **Flaky sea salt** can add a delectable crunch as a finishing salt, but don't use it in place of the granulated stuff, because it measures differently. **Kosher salt** forms with larger crystals, and works best on meat as a tenderizing agent or as a finishing salt. If you use it in your baked goods, you might get an unpleasant salty bite because it can't mix in properly.

# Dairy

Most dairy products can be replaced with a vegan option for those who have lactose intolerance or need dietary accommodations. Vegan butter is just as good as the regular stuff, as well as lactose free milk or alternative milks. Oat milk is slightly naturally sweet, and is my go-to milk replacement. There are tons of egg replacement products, or you can make flax eggs, or use applesauce. However, sometimes the binding can be compromised, so make sure to test out the replacement before you commit to a big batch.

# Butter

In all of the recipes following, I call for unsalted butter. This allows you to have more control over the flavor of the finished dish, and the salt content can be balanced. This also makes it easier for you because you only need to buy one type of butter.

# Eggs

Look for large eggs in the grocery store. Eggs with brown shells are generally tastier than eggs with white shells, though every producer is different. If you can afford cage free and organic, do it.

# Milk

**Whole milk** has a fat content of about 3 ½%, and skim has virtually no fat content. It's up to you to choose which milk to keep in your fridge, though I find that **2% milk** is the perfect balance for drinking, making cereal, and baking. It has enough fat so it's flavorful, but not so much that you need to feel guilty about it. Again, if alternative milks are for you, **oat milk** is my go-to, and almond or coconut milks can add excellent flavor to a treat, though it is quite watery, so be wary of that.

**Buttermilk** is acidic, so it will react with your leavener. It adds great flavor to pancakes and other items, and you can find it powdered so you can use it when you need it.

# Cream Cheese, Sour Cream, Yogurt, etc.

These dairy products are the ones that you can just pick up from the store when you need them. Cream cheese is perfect for angelic frostings or cheesecakes, sour cream and yogurt add structural balance and moistness to a batter.

# Fats

**Butter** is the fat that most recipes call for, oil being a close second. Olive, vegetable, or any other **neutral oil** can be used for most recipes. **Shortening** is a hardened vegetable fat and has a higher melting point to help keep desserts stable, and can replace butter in most cases. **Lard** is an animal product that I typically don't keep in my kitchen.

# Flavorings

Vanilla is a staple for most baked goods, adding a warm aromatic scent and elevating any flavor profile. There are two main types of vanilla flavoring: **vanilla extract**, which is pure, less processed, and more expensive. Basically, it tastes better, and since it's used in basically every recipe, I recommend this one. You can find it in a liquid or a paste form, though the recipes below use the liquid measurements. If you use vanilla paste, use a little less than the recipe calls for. The other type of vanilla is **vanilla essence**, AKA imitation vanilla, and it's lower quality. It's made of chemicals mixed to taste like vanilla, and even though the price tag might entice you, don't go for it.

If you can find them and have the budget, **whole vanilla beans** are a treat. You can scrape the seeds out with a paring knife and use them like you would vanilla paste, and soak the pods in vodka for a couple months to make your own vanilla extract.

The other common extract that you'll likely use is **almond extract**. This stuff is super potent, and you only need a tiny bit to taste it. There's a million extracts you can purchase (lemon and peppermint, for example), but you use these much less frequently, so you can just get them when you need them.

**Liqueur** is another way to flavor your desserts. Amaretto liqueur, orange liqueur, and others are spirits that have been infused with a flavoring and can elevate a dessert. Be careful not to serve this to your kids unless all of the alcohol is cooked out.

# Spices

If the ground spices in your pantry are over a year old or have no smell, it might be time to get some new ones. Cinnamon, nutmeg, all-spice, star anise, ginger, cardamom, and black pepper are all pantry staples. Basil, rosemary, and thyme are the herbs that I recommend.

As for storage, everyone knows how much of a headache spice organization can be. Consider investing in a rotating spice rack, or a magnetic one that you can keep on the side of your fridge.

# Add-Ins

Taste is personalized and not entirely in your control. Sometimes you wish that you (or your picky kids) would learn to love an ingredient, but no matter how many times you try it, it's just not appetizing. There's no need to suffer, you can take out or add anything into these recipes. Just keep in mind how it will affect the dish as it bakes (water/fat content, etc).

Semi sweet or milk chocolate chips/chunks are a sweet addition to any treat. Marshmallows or sprinkles are another way to make your kids happy.

Dried fruits like raisins, sultanas (golden raisins), dried cranberries, and apricots are all fiber-rich additions to any bake. Nuts like cashews, walnuts, and almonds can be stored in the fridge or freezer to lengthen shelf life.

Jams and jellies of any variety (the classics like strawberry or grape jellies can be found at any supermarket, and you can even find apple or pineapple preserves) add a tart flavor to fillings. Next to them on the shelf, nut butters like peanut or almond can enhance the flavor of cookies or cakes.

I keep one set of natural food dyes in my pantry and they work great! Any other highly processed items just aren't in my cupboards.

Now that you have an arsenal of cooking supplies, it's time to get in the kitchen. The next section covers the easiest and most approachable recipes in the book. One more hurdle you'll have to face: the dishes. If you don't have a dishwasher, try to wash as you go, washing the dishes from your last step before you jump into the next one, if you can. Otherwise, you'll have time to wash while the item is in the oven. Staying on top of things will lessen your headache later, and you won't subconsciously pair baking with exhaustive labor.

Besides, if you get your kids excited and they join you in the kitchen, you might be able to motivate them with the smell of baking brownies to do the dishes for you.

# Chapter 2:

# Appetizing After-School Snacks

Though my kids weren't the pickiest of eaters, I struggled to find snacks for them that they would finish. Sometimes my snacks were a miss: too obviously healthy or 'boring,' as they would put it. I was frustrated when more often than not they would turn to pre-packaged, overly processed garbage that I knew was giving them no nutritional value.

It took months for me to gather a repertoire of recipes that my kids love. They request these options from me all the time now, and get excited to come home when they know what little treat is waiting for them. School and adolescent life can be stressful, and I like to make the transition out of it a little easier so they can detox from the day and relax. When my kids get a snack after school, it improves their energy, which means that they can tackle that homework, and they don't whine until dinnertime.

Filled with easy sweet and savory recipes, these gems can be made in advance and keep the kids happy all week long.

# Chocolate Avocado Pudding

Avocado is an awesome vegetable-like-fruit (yes, avocado is a fruit) that can be thrown into almost anything to add a boost of nutrients, especially good fats and omega 3s. The velvety texture that this adds to the pudding can't be beat. This recipe is vegan and easy to whip up in a flash!

**Servings:** 4
**Prep Time:** 10 minutes
**Cook Time:** 0 minutes
**Chilling Time:** 2 hours
**Total Time:** 10 minutes

## Ingredients:

2 ripe avocados, peeled and pitted
4 tablespoons cocoa powder
1/2 cup almond milk
4 tablespoons pure maple syrup or agave
1 teaspoon vanilla extract
1 tablespoon hemp or chia seeds, optional

## Instructions:

1. In a blender or food processor, combine all ingredients and blend on high until smooth, scraping down the sides if necessary. Add more almond milk if needed, a tablespoon at a time, until desired thickness is reached.
2. Use a spoon to taste for sweetness, adding more cocoa powder or maple syrup if needed.
3. Chill for two hours in the fridge, or eat right away. Top with whipped cream, coconut, or any toppings of your choice.
4. Store in an airtight container in the fridge for up to four days. Best served chilled.

# Quick Banana Pudding

This recipe is super adaptable and an empty canvas for all sorts of flavors! This classic pudding is a perfect match for bananas, but could be substituted with any other fruit or flavoring of your choice. This stuff is surprisingly delicious, and you won't be able to go back to the store-bought stuff after having a bite. Though the time it takes to chill might require some patience, you'll only be spending a few minutes over the stove, and you can make big batches that will stay good in the fridge for a long time. Simple and sweet, what else could you ask for?

**Servings: 4**
**Prep Time: 5 minutes**
**Cook Time: 8 minutes**
**Chilling Time: 2 hours**
**Total Time: 2 hours 13 minutes**

## Ingredients:

2 cups milk
2 egg yolks
1 teaspoon vanilla
¼ cup white sugar
3 tablespoons cornstarch
½ teaspoon salt
2 large bananas, sliced

# Instructions:

1. In a medium pot, whisk all ingredients well (except the bananas, which will be used for serving) while the heat is off.
2. Turn heat to medium, whisking frequently to prevent clumping. Once boiling, cook for about two minutes, or until mixture thickens and can coat the back of a spoon.
3. Transfer to pudding containers or a serving container, covering with plastic wrap, making sure that the surface of the wrap touches the contents, so a skein doesn't form while chilling.
4. Chill in the fridge for two hours or overnight and serve with sliced bananas. Serve immediately after taking it out of the fridge and enjoy!

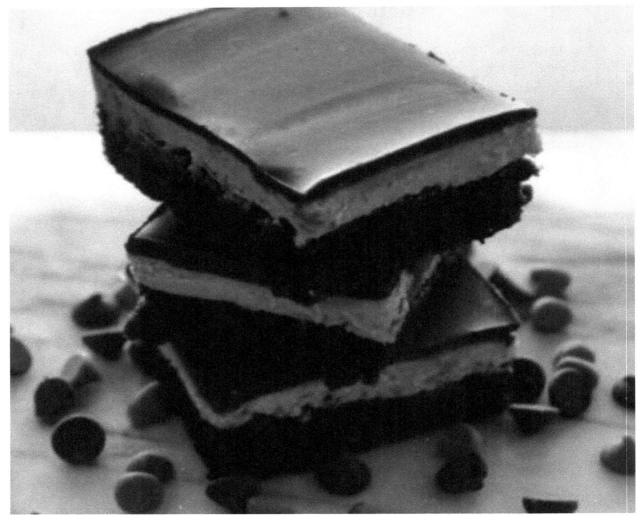

# Buckeyes

This homemade candy will be a staple in your fridge for when you or your kids need a one-bite pick-me-up. Instead of buying pre-packaged peanut butter cups, make this six ingredient recipe, so you can SKIPPY the unnecessary additives. Get it? Like the Skippy brand peanut butter? Jif works too, or any smooth, salty variety. If you're looking for the added texture, chunky peanut butter will also work.

**Servings: 24 buckeyes**
**Prep Time: 15 minutes**
**Cook Time: 0 minutes**
**Chilling Time: 20 minutes**
**Total Time: 35 minutes**

# Ingredients:

1 cup peanut butter
- 5 tablespoons unsalted butter, softened to room temperature
- 2 cups powdered sugar
- 1 teaspoon vanilla
- 2 cups semi sweet chocolate
- 2 tablespoons coconut oil

# Instructions:

1. In a large bowl with a hand mixer or in a stand mixer, cream together softened butter and powdered sugar. Add vanilla.
2. Add powdered sugar a ½ cup at a time, scraping down the sides of the bowl with a rubber spatula in between mixings.
3. Once combined, roll the dough into ball shapes with your hands (approximately 1 tablespoon each).
4. Place the balls on a lightly greased baking pan or wax paper and chill for 20 minutes. Insert a toothpick into the top of each one.
5. While chilling, melt the chocolate. If you have a microwave, melt the chocolate and coconut oil in a microwave-safe bowl over medium power in 1 minute increments, mixing between. Once chocolate is 75% melted, stir vigorously until smooth. If you don't have a microwave, use the double boiler technique. In a medium sized pot, heat about an inch of water to a simmer. Choose a glass or metal bowl, shallow enough so the bottom of it doesn't touch the water. Add chocolate and coconut oil and stir constantly until chocolate is 75% melted. Turn off heat and mix vigorously until smooth.
6. Dip peanut butter balls in the chocolate, leaving about ¼ of the peanut butter ball surface visible for the classic buckeye look.
7. Place back onto the baking sheet or wax paper, remove the toothpicks and chill until chocolate has hardened.
8. Buckeyes should be kept covered in the fridge, and can last up to two weeks, if you don't eat them all before then!

# Rice Krispies Treats

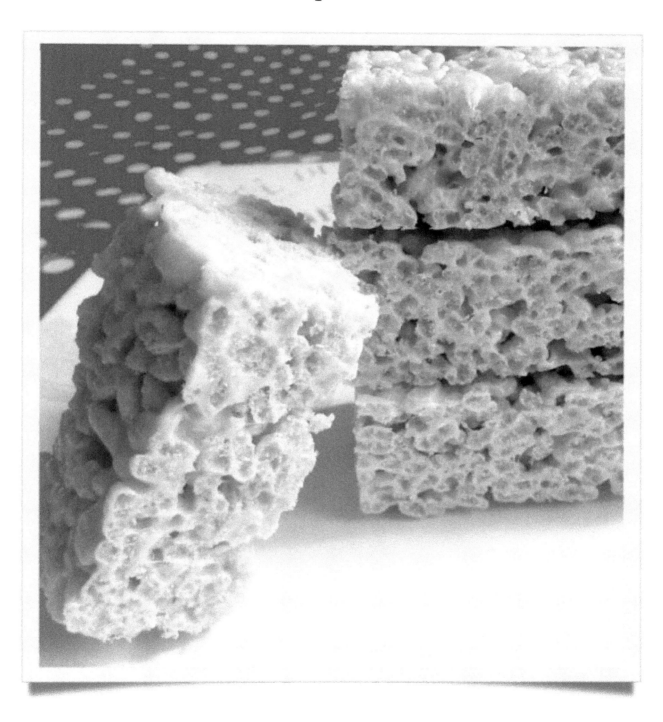

Nostalgic, crunchy, and with a surprising amount of dissent around the name (is it rice crispies, rice crispy, crispy rice, or rice krispies!?). This no-bake, four ingredient snack comes together in a flash and is perfect for when you're on-the-go.

**Servings: 9 large bars or 12 smaller bars**
**Prep Time: 5 minutes**
**Cook Time: 5 minutes**
**Chilling Time: 1 hour**
**Total Time: 1 hour 10 minutes**

# Ingredients:

6 cups rice krispies cereal

16 oz bag of mini marshmallows (approximately 8 cups), with one cup saved (8-9 cups total)

6 tablespoons salted butter

1 teaspoon vanilla

## Instructions:

1. Line a 9x13 inch baking sheet (or 9x9 inch square baking sheet) with parchment paper, and set it aside.
2. In a large saucepan over medium heat, melt the butter. Once melted, add in all of the marshmallows, save one cup. Reduce heat to low and stir for about 3 minutes until marshmallows have melted entirely.
3. Turn off heat and allow mixture to cool for one minute. Then, stir in vanilla and the remaining cup of marshmallows. Stir in the rice krispies cereal one cup at a time until combined.
4. Pour into the prepared baking sheet and gently press the mixture into the pan, trying not to deflate the mixture too much. Allow to set at room temperature for about one hour, then cut into squares using a lightly greased knife. Enjoy!

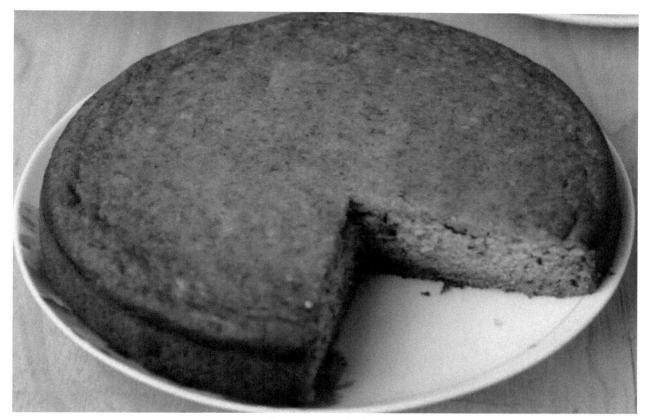

## Banana Cake

Bananas are a naturally sweet way to increase the amount of fiber in your kids' diets! Moist, simple, and certain to make your kitchen smell like a dream, this is the first baked item in this recipe book. So if you were dipping your toes with the no-bake desserts, don't be intimidated by the prospect of dusting off your oven. This recipe is foolproof, and once you realize how easy baking really is, the world will be your oyster.

**Servings: 8 slices**
**Prep Time: 5 minutes**
**Cook Time: 35 minutes**
**Chilling Time: 0 minutes**
**Total Time: 40 minutes**

## Ingredients:

½ cup butter
1 egg
¾ cup white sugar
1 ½ cups self-rising flour
¼ cup milk
1 teaspoon vanilla
2 ripe, mashed bananas

## Instructions:

1. Grease a 9 inch round pan with a circular piece of parchment paper at the bottom, also greased. Set to the side. Preheat the oven to 350°F.
2. In a medium sized saucepan over medium heat, melt together butter and sugar. Take off the heat and stir in vanilla.
3. In a large bowl, mash bananas and add in the contents from the saucepan. Stir in the egg, and mix together very well.
4. Stir in the flour a ½ cup at a time, mixing until only barely incorporated.
5. Pour in the milk and fold batter together, careful to not overmix.
6. Transfer batter to the greased round pan and bake on the middle rack for approximately 35 minutes, or until a toothpick comes out cleanly from the center.

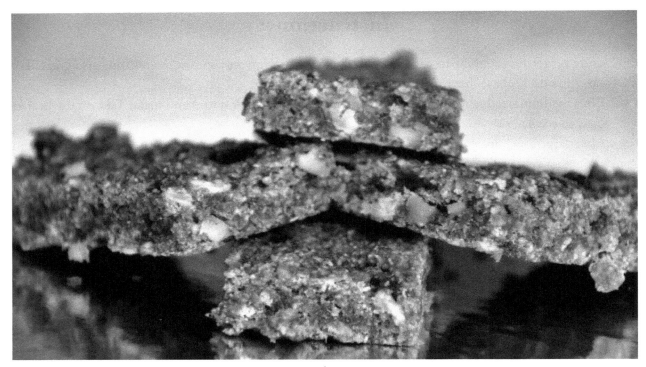

# Muesli Bars

Packed with superfoods, muesli bars are a classic that you can make so easily at home, and this healthy snack will be sneakily delivering your body vitamins, nutrients, and fiber.

**Servings: 12 bars**
**Prep Time: 10 minutes**
**Cook Time: 40 minutes**
**Chilling Time: 0 minutes**
**Total Time: 50 minutes**

## Ingredients:

¼ cup butter
¼ cup packed brown sugar
¾ cup honey
3 cups muesli or rolled oats
1 cup sultanas or golden raisins
¼ cup pumpkin seeds
¼ cup sunflower seeds
1 teaspoon ground cinnamon

## Instructions:

1. Grease a 7x9 inch loaf pan, and preheat the oven to 350°F.
2. In a medium saucepan over medium heat, combine butter, brown sugar, and honey, and stir constantly for about 5 minutes, or until butter and sugar are completely dissolved.
3. Once boiling, cook for an additional 2 minutes, stirring constantly, until the sauce thickens and can coat the back of a spoon. Remove from heat.
4. In a large bowl, combine muesli, sultanas, pumpkin seeds, sunflower seeds, and cinnamon, and pour syrup on top. With a wooden spoon, stir the contents together thoroughly.
5. Spoon mixture into greased loaf pan and press down on the mixture with the back of a spoon to spread.
6. Bake in the oven for approximately 40 minutes, or until golden brown.
7. Slice and enjoy!

# Chocolate Chip Oaty Slice

Like a healthier version of a chocolate chip cookie, this hearty oat bar is full of sweet chocolate chunks packed in a crumbly, nutty base. Easy to package and take on the go, this treat is a no brainer for lunches or a quick after-school snack.

**Servings:** 15 bars
**Prep Time:** 10 minutes
**Cook Time:** 20 minutes
**Chilling Time:** 0 minutes
**Total Time:** 30 minutes

## Ingredients:

½ cup flour
 ½ cup self-rising flour
 1 cup rolled oats
 ½ cup butter, melted
 1 egg
 ⅔ cup dried coconut
 ⅔ cup packed brown sugar
 ⅔ cup milk chocolate chunks

## Instructions:

1. Grease a narrow baking sheet (9x13 inch or 8x10 inch for thicker bars), placing a large sheet of parchment paper on the bottom, with overhanging edges on two sides for easy removal. Preheat the oven to 350°F.
2. In a large bowl, sift in flour and add oats, brown sugar, coconut, and chocolate chunks.
3. In the center of the dry ingredients, dig a well and pour the melted butter and the egg, lightly whisked, into the well.
4. Using a wooden spoon, stir together. Spoon mixture into the prepared baking pan and flatten with the back of the spoon.
5. Bake for 20 minutes or until golden and firm to the touch. Allow to cool before cutting into squares and enjoying.

# No-Bake Energy Balls

No time? No energy? These one-bite wonders will shock you with how easy they are to mix up, compared to the burst of happiness that comes when you eat one. Good thing they're so easy, because your entire household will be begging for you to make another batch. They'll keep in the fridge for about a week in a sealed container, or 3 months in the freezer.

**Servings: 20-25 balls**
**Prep Time: 20 minutes**
**Cook Time: 0 minutes**
**Chilling Time: 1 hour**
**Total Time: 1 hour 20 minutes**

## Ingredients:

1 cup rolled oats
 ½ cup ground flaxseed
 1 tablespoon chia seeds
 ⅔ cup dried coconut
 ½ cup peanut butter
 ⅓ cup honey
 ½ cup chocolate chips
 1 teaspoon vanilla

## Instructions:

1. In a large bowl, stir all ingredients together.
2. Cover the mixing bowl with plastic wrap or an air-tight lid, and chill in the fridge for an hour or longer.
3. Remove from the fridge and roll into 1 inch balls using the palms of your hands.
4. Either enjoy immediately or store sealed in the fridge or freezer.

## Strawberry Fruit Roll Ups

Skip the store-bought and try something new! From the grocery store, these treats are mostly made up of artificial flavors and an overdose of red dye, not to mention the horrible ultra-processed sugars. This all natural alternative is made out of ingredients you can pronounce the names of: just strawberries and lemon juice.

**Servings: 3 rolls**
**Prep Time: 5 minutes**
**Cook Time: 4 hours**
**Chilling Time: 0 minutes**
**Total Time: 4 hours 5 minutes**

## Ingredients:

8 oz (1 cup) fresh strawberries, stems removed
    1 tablespoon lemon juice
    2 tablespoons sugar or sweetener (optional)

## Instructions:

1. Preheat the oven to 170°F, or as low as your oven allows. Don't use heat higher than 200°F.
2. In a blender or food processor, blend strawberries for about a minute until they have become completely pureed.
3. Transfer mixture to a small saucepan and turn heat to medium. Add in lemon juice and optional sugar.
4. Cook for approximately 10 minutes, stirring frequently, until jammy. This is in an effort to cook out any extra moisture.
5. On a baking sheet lined with a slipmat or parchment paper, spread the mixture with a spatula so it's even, making sure to have no spots thicker than ⅛ of an inch and no spots so thin you can see through it.
6. Dehydrate in the oven for 3 or 4 hours until the mixture is tacky but not sticky, cracking the oven open every hour to allow extra moisture to be released.
7. Allow to cool completely and then cut into ribbons with a pizza cutter. Roll the ribbons into the classic fruit roll up shape, and enjoy!

## Crunchy Cornflake Cakes

When you're tired and you feel like the only thing in the house to snack on is the cereal you just ate for breakfast, make these easy desserts out of it instead.

**Servings: 6-8 cakes**
**Prep Time: 5 minutes**
**Cook Time: 10 minutes**
**Chilling Time: 0 minutes**
**Total Time: 15 minutes**

## Ingredients:

4 cups cornflakes cereal
1 cup white sugar
3 tablespoons butter
1 tablespoon honey

## Instructions:

1. Preheat the oven to 300°F.
2. In a small saucepan on medium low heat, stir together the butter, sugar, and honey until frothy.
3. In a medium bowl, mix together cornflakes and hot syrup mixture.
4. Spoon into cupcake liners and bake for 1o minutes.

If you wanted to step these desserts up to the next level, you can melt chocolate with butter or coconut oil and drizzle it over the tops of these once they've baked, or add sprinkles, jam, or anything you'd like.

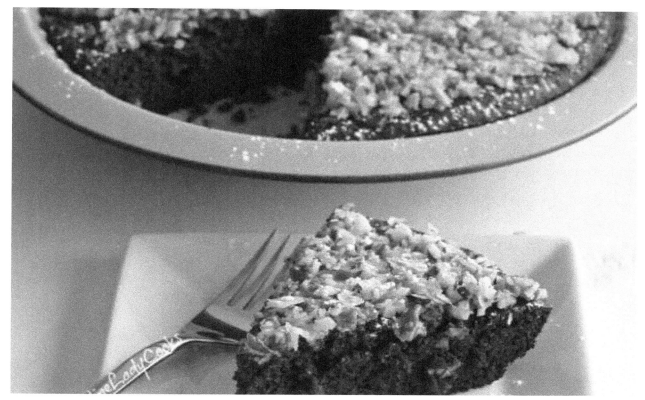

## Coconut Brownie Bites

Coconut and chocolate, a match made in heaven. The best part? They're healthy. This recipe adheres to the paleo diet, which basically means that they're low in carbs and high in protein. Your kids won't even notice that they're good for them, they'll just be thinking *brownie bites brownie bites brownie bites!!!*

**Servings: 25-30 balls**
**Prep Time: 5 minutes**
**Cook Time: 0 minutes**
**Chilling Time: 30 minutes**
**Total Time: 35 minutes**

## Ingredients:

1 cup packed raisins
1 cup cashews
⅓ cup dried coconut
¼ cup cocoa powder
¼ teaspoon salt
¼ teaspoon cinnamon
1 teaspoon vanilla

## Instructions:

1. In a medium bowl, submurge raisins in hot water and allow to soak for 5 minutes, then drain and dry.
2. Add soaked raisins and all other ingredients (except the coconut; spread the shreds onto a plate and set aside) to a food processor or blender. Pulse until the texture is sticky and crumbly, like the texture of wet sand.
3. Remove the dough and shape into 1 inch balls using the palms of your hands.
4. Roll each ball in the shredded coconut and place on a baking sheet lined with parchment paper or in an airtight container and chill for 30 minutes before enjoying.

# Healthy Homemade Fruit Gummies

Though this recipe does require a specialty mold, the results are just so cute that you'll have to run out and buy it (you can get them for less than $10!). With the molds there are usually accompanying eye-droppers, which you will need, but you can also buy it separately. This recipe is great if you kids are avid fans of the gummy texture and you're not a huge fan of the chemicals or plastic packaging, and putting a little love into making them from scratch will be a huge positive for everyone.

**Servings: 70 gummies**
**Prep Time: 5 minutes**
**Cook Time: 20 minutes**
**Chilling Time: 30 minutes**
**Total Time: 55 minutes**

## Ingredients:

⅓ cup fruit juice of choice (apple, orange, lemon, grapefruit, cherry, and grape are all great choices!)
   2 teaspoons white sugar
   2 tablespoons honey
   1 tablespoon (one envelope) unflavored gelatine

## Instructions:

1. Place your gummy bear shaped gelatine molds onto a large baking sheet for easy transport, and clear a large flat area of the fridge where they will set.
2. If you choose to make more than one flavor, cook them all separately.
3. In a small saucepan, combine all ingredients, saving the gelatine. Bring this mixture to a boil, and then remove from the heat and allow to cool until still warm, but not hot. It should only cool for about 3 minutes.
4. In a separate small bowl, bloom your gelatine. Do this by combining the tablespoon of gelatine from the package and one tablespoon of lukewarm water, stirring until all contents are dissolved. The mixture should become rather thick while you stir it.
5. Add the bloomed gelatine to the warm fruit mixture.
6. Immediately take your eye dropper and begin to fill the gummy molds, Make sure the molds are filled completely, while trying not to let them overflow.
7. Carefully transfer the baking trays full of soon-to-be gummy bears to the fridge and chill for 30 minutes.
8. Once set, pop them out of the molds and enjoy!

# Cranberry Almond Oatmeal Bars

Perfect for a quick breakfast, snack, or a healthy dessert, these hearty oatmeal bars are good for you and pack a perfect burst of energy. They require very little effort to make and keep in the fridge or at room temperature for about a week. They're also a perfect canvas to customize! You can add in hemp seeds and pepitas for a crunchy granola bar, or substitute the cranberries with dried mangos or apricots.

**Servings: 12 bars**
**Prep Time: 10 minutes**
**Cook Time: 0 minutes**
**Chilling Time: 30 minutes**
**Total Time: 40 minutes**

## Ingredients:

2 cups rolled oats
½ cup sliced almonds
½ cup dried cranberries
½ cup vanilla protein powder
½ cup almond butter
½ cup honey, agave, or maple syrup
2 tablespoons cinnamon
¼ teaspoon salt

## Instructions:

1. Prep a 9x9 inch square pan by lining it with parchment paper.
2. In a medium bowl, mix together all ingredients with a rubber spatula.
3. Transfer the dough to the prepared pan, spreading and flattening it evenly with the spatula.
4. Place in the fridge and chill for 30 minutes.
5. Cut into squares and enjoy!

# Homemade Granola

Whether you're going on a family hike or just embarking on a long car ride, this granola will be a hit. It's kid-approved, but still made of whole ingredients, without much added sugar. Easy to dose into individual snack bags, this granola will last forever and aid you on any adventure you set out on. It's the perfect crunch to add to your morning oatmeal or peanut butter toast, yogurt, or anything that you like.

**Servings: 12 cups**
**Prep Time: 10 minutes**
**Cook Time: 30 minutes**
**Chilling Time: 0 minutes**
**Total Time: 40 minutes**

# Ingredients:

6 cups rolled oats
    ¼ cup brown sugar
    ½ cup coconut oil, room temperature
    ⅓ cup honey or agave
    2 teaspoons vanilla
    1 cup chopped walnuts or cashews
    ¼ cup sunflower seeds or pepitas
    ½ cup raisins
    1 cup coconut flakes
    1 cup candy coated chocolate (optional)

## Instructions:

1. Preheat the oven to 350°F and spray a large baking sheet with nonstick spray.
2. In a large bowl, mix together oats and brown sugar, then fold in the nuts and seeds.
3. In a separate bowl, whisk together honey, vanilla, and coconut oil.
4. Pour the wet mixture over the dry, and stir together.
5. Spread mixture over prepared baking sheet and bake for 30 minutes, mixing every five minutes for even browning.
6. Once golden brown, remove from the oven and allow to cool on the baking sheet.
7. Break up any large pieces and stir in dried fruit, coconut, and chocolate (only add chocolate after the mixture is completely cool).
8. Store in an airtight container and enjoy for up to 3 weeks.

# Healthy Carrot Cake Muffins

Made with whole grains and no refined sugars, these protein rich muffins sneak in a huge serving of vegetables, are a gorgeous color, and can be topped with cream cheese frosting if your kids need a "cupcake." Lucky for you, this is the healthiest cupcake in the land. And, lucky for your kids, they'll be getting a ton of nutrients to help them grow.

**Servings: 12 muffins**
**Prep Time: 15 minutes**
**Cook Time: 13 minutes**
**Chilling Time: 0 minutes**
**Total Time: 28 minutes**

## Ingredients:

2 cups peeled and grated carrots
⅓ cup melted coconut oil or olive oil
½ cup honey or agave
2 eggs
1 cup greek yogurt
1 teaspoon vanilla
1 ¾ cups whole wheat flour
1 ½ teaspoons baking powder
½ teaspoon baking soda
½ teaspoon salt
1 teaspoon cinnamon
½ teaspoon nutmeg
½ teaspoon ginger
½ cup golden raisins
½ cup chopped walnuts
1 teaspoon turbinado sugar (aka raw sugar, sanding sugar) for topping

## Instructions:

1. Preheat the oven to 425°F and grease 12-cup muffin tin with nonstick spray.
2. In a large bowl, combine the dry ingredients (flour, baking powder, baking soda, cinnamon, nutmeg, and ginger). Whisk together until incorporated.
3. In a separate small bowl, toss golden raisins in about a tablespoon of flour so they don't sink to the bottom of your batter. Add floured raisins, grated carrots, and chopped walnuts to the dry ingredients.
4. In a separate medium bowl, combine coconut oil and honey or agave. If you're worried about the coconut oil firming up, warm the honey in the microwave for about 30 seconds. Add in the eggs and beat well, then add in the yogurt and vanilla.
5. Fold the wet ingredients into the dry until just combined, and spoon into the greased muffin tin evenly.
6. Top with turbinado sugar and bake for 13-16 minutes, or until a toothpick comes out cleanly.
7. Store covered on the counter for two days, in the fridge for four, or in the freezer for up to 3 months.

# Hearty Homemade Sausage Rolls

Like an upgraded pig-in-a-blanket, these sausage rolls are popular all over the world, and make a perfect savory breakfast. Cut into perfect protein-packed portions, these are sure to warm your chest and your soul, and will set you on the path to having a better day. Vegan or vegetarian sausages work perfectly here too.

**Servings: 20 rolls**
**Prep Time: 20 minutes**
**Cook Time: 30 minutes**
**Chilling Time: 10 minutes**
**Total Time: 1 hour**

# Ingredients:

1lb ground pork
- 5oz bacon, minced
- 1 small white onion
- 1 celery stalk
- 2 garlic cloves, minced
- ¾ cup panko breadcrumbs
- 2 eggs
- ½ teaspoon salt
- 1 teaspoon pepper
- 1 teaspoon fennel
- ½ tablespoon oil
- 2 ½ sheets puff pastry
- 1 tablespoon ketchup

# Instructions:

1. Preheat the oven to 350°F.
2. In a medium non-stick frying pan over medium heat, sauté onion and celery in oil until fragrant and tender. Add in garlic and minced bacon, and sauté until bacon is cooked but not crispy. Allow this mixture to cool for 10 minutes while you prepare the rest.
3. Slice each piece of puff pastry in half. Lay out each piece on a large greased baking sheet. Whisk together one egg in a separate small bowl and using a pastry brush, apply the egg wash to the long edges closest to you.
4. Add in the rest of the ingredients to the cooked mixture from before (ground pork, one egg, breadcrumbs, and spices; saving the ketchup for dipping).
5. Spoon about ⅕ of the filling into the middle of each rectangle of puff pastry. Roll the puff pastry around the filling, making sure that there are no gaps. Flip so they bake seam side down, and brush all logs with egg wash.
6. Cut logs into four slices (or to desired thickness) and bake in the oven for 30-35 minutes, swapping tray shelves about 20 minutes in. You'll know they're done when the pastry is deep golden brown, even though the filling might still be a bit pink because of the bacon. If you're nervous about the color, cook them longer.
7. Serve hot or rewarmed with ketchup, and enjoy!

# Mini Quiches

A quick and easy breakfast idea that can be customized any way you want them! The fillings are up to you and your family's tastes, but I've provided you with some classics that are kid-friendly and still might trick them into eating a vegetable if they sample all the flavors you made. If they absolutely refuse, though, there's also a portion of plain quiches that will satisfy any toddler on a hunger strike. With special mini muffin tins, you can easily replicate at home what coffee shops charge a huge price for, and you can easily feed your whole family efficiently.

**Servings: 48 quiche bites**
**Prep Time: 25 minutes**
**Cook Time: 30 minutes**
**Chilling Time: 0 minutes**
**Total Time: 55 minutes**

# Ingredients:

4 thawed pie crusts (2 store-bought boxes)

**Egg Mixture:**

4 eggs

1 cup milk

½ teaspoon salt

½ teaspoon pepper

**Mini Quiche Lorraine:**

½ white onion, caramelized

3 slices bacon, cooked and crumbled

¼ cup shredded swiss cheese

**Mini Croque Monsieur Quiche:**

¼ cup cubed ham

¼ cup shredded swiss cheese

1 tablespoon dijon mustard

**Mini Veggie Quiche:**

2 cups wilted spinach

2 tablespoons mushrooms, chopped

1 tablespoon cubed red bell peppers

¼ cup shredded swiss cheese

**Plain Quiche:**

¼ cup shredded swiss cheese

## Instructions:

1. Allow pie crusts to sit at room temperature for about 10 minutes on a lightly floured surface. Preheat the oven to 375°F, and grease 48 miniature muffin tins with nonstick spray. Unroll the crusts and cut out 12 rounds from each of the four pie crusts with a biscuit cutter or a cup, about 2-2 ½ inches in diameter.
2. Press each round into the greased mini-muffin divots, making sure to press the dough up the sides.
3. In a large liquid measuring cup, whisk together the egg mixture (eggs, milk, and salt).
4. To assemble the **Mini Quiche Lorraine**, begin by caramelizing one small sliced onion (neutral cooking oil and onions in a pan over medium heat, adding a little water, brown sugar, and balsamic vinegar if desired) until the onions are soft and golden brown, and layer the onion jam onto the bottoms of twelve of the mini quiche-dough divots. Evenly divide the bacon and cheese into the 12 quiches (about ½ tablespoon crumbled bacon and 1 tablespoon cheese).
5. To assemble the **Mini Croque Monsieur Quiche**, spread a thin layer of dijon mustard into 12 of the mini muffin tins. Evenly divide the ham and cheese into the 12 quiches (½ cubed ham and 1 tablespoon cheese).
6. To assemble the **Mini Veggie Quiche**, wilt the spinach in a medium saucepan over medium heat—you can use the bacon greased pan from before—with a ¼ cup of water and cook until spinach is wilted and dark green. Spoon evenly into 12 of the quiches, about a ½ teaspoon in each. Evenly divide the red pepper cubes and mushrooms.
7. To assemble the **Plain Quiche**, divide about 1 tablespoon of cheese into the remaining 12 quiche spots.
8. Pour the egg mixture over each of the 48 quiches, filling them almost all the way to the top.
9. Bake for 25-30 minutes, serve warm and optionally top with sliced scallions.

# Sweet Potato, Spinach, and Feta Muffins

These savory muffins are the perfect lunchbox snack, a great carb to pair with an omelet or dip in a soup, and will definitely trick your kids into eating some dark leafy greens. The sweet potato in the muffin batter creates a luxurious, rich texture, and the creamy pockets of feta swirl perfectly with the soft spinach to create an all around awesome mouth-feel.

**Servings: 12 muffins**
**Prep Time: 5 minutes**
**Cook Time: 30 minutes**
**Chilling Time: 0 minutes**
**Total Time: 35 minutes**

## Ingredients:

1 cup all-purpose flour

1 cup whole wheat flour

1 teaspoon baking soda

¼ cup spinach, wilted and chopped

2 shallots, thinly sliced

½ cup feta, crumbled

¼ cup grated parmesan

2 eggs, beaten

⅔ cup yogurt

1 cup creamed corn

1 cup sweet potato puree

¼ cup melted butter or coconut oil

## Instructions:

1. Preheat the oven to 350°F. Grease 12-count muffin tin with nonstick spray.
2. Wilt spinach in the same manner as the recipe prior.
3. Sift together the plain and whole wheat flours with the baking soda, then stir in spinach, half the feta, and the thinly sliced shallots.
4. In a separate bowl, whisk together the creamed corn, sweet potato puree, parmesan, beaten eggs, yogurt, and melted butter.
5. Fold the wet into the dry until just combined. Spoon mixture evenly into the prepared tin and crumble the remaining feta on top.
6. Bake for 30 minutes or until a toothpick comes out cleanly, and enjoy!

# Cheese and Bacon Puffs

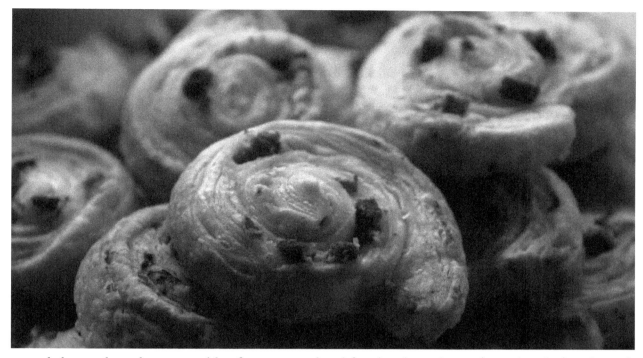

Bacon and cheese, the only pair capable of conquering breakfast, lunch, or dinner (I won't judge) and satisfy the craving of a sneaky salty midnight snack. These light and fluffy biscuits make the perfect vessel to dip into your favorite sauce, and you might need to make a double batch to satisfy the demands of your kids after they try one.

**Servings: 12 puffs**
**Prep Time: 10 minutes**
**Cook Time: 20 minutes**
**Chilling Time: 0 minutes**
**Total Time: 30 minutes**

# Ingredients:

1 cup self-rising flour

    2 cups grated cheddar cheese

    ½ cup milk

    4 strips bacon, cooked and chopped

    1 large onion, finely chopped

    1 egg

    1 teaspoon dijon mustard

    ½ cup scallions

    salt and pepper to taste

## Instructions:

1. Preheat the oven to 350°F and grease a large baking sheet. Optionally, line it with parchment paper.
2. In a large bowl, combine cheese, bacon, chopped onions and scallions, flour, salt and pepper.
3. Beat the egg with the milk and mustard, then fold into the dry ingredients.
4. Spoon rounded mounds of batter onto the prepared tray, allowing them room to spread.
5. Bake for approximately 20 minutes, and serve with ranch, BBQ sauce, hot sauce, or anything you desire. Best served warm.

# Ham and Pineapple Pinwheels

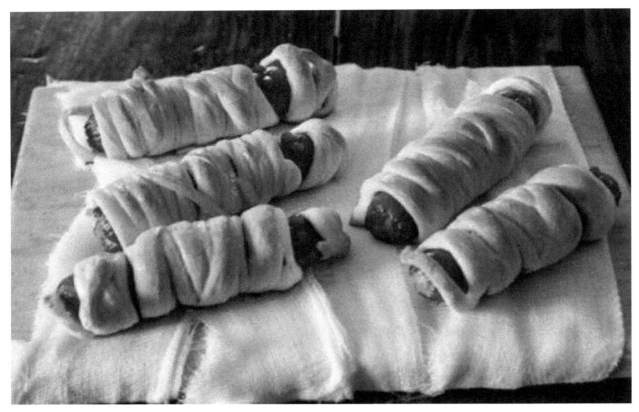

For kids who are looking to branch out and try a hybrid of sweet and salty flavors, these fun pinwheels will totally satisfy that craving! Perfect for Hawaiian Pizza lovers, this funky favorite is simple and only has four ingredients.

**Servings: 5 pinwheels**
**Prep Time: 10 minutes**
**Cook Time: 15 minutes**
**Chilling Time: 5 minutes**
**Total Time: 30 minutes**

## Ingredients:

1 sheet puff pastry
    2 diced pineapple rings (or about ½ a can of diced pineapple, drained well)
    ½ cup diced ham
    ½ cup shredded mozzarella cheese
    1 tablespoon tomato paste

## Instructions:

1. Preheat the oven to 350°F and grease a baking sheet.
2. Roll out puff pastry and spread tomato paste evenly. Spread diced ham, diced pineapple, and sprinkle with cheese.
3. Cut pastry in half if you want to make it easier to roll. Begin to roll from the side closest to you and roll the pastry in a tight spiral shape.
4. Place in the freezer for five minutes to chill. Slice into 1 inch slices, and bake face-side up for 13-15 minutes.
5. Enjoy!

# Tasty Pizza Muffins

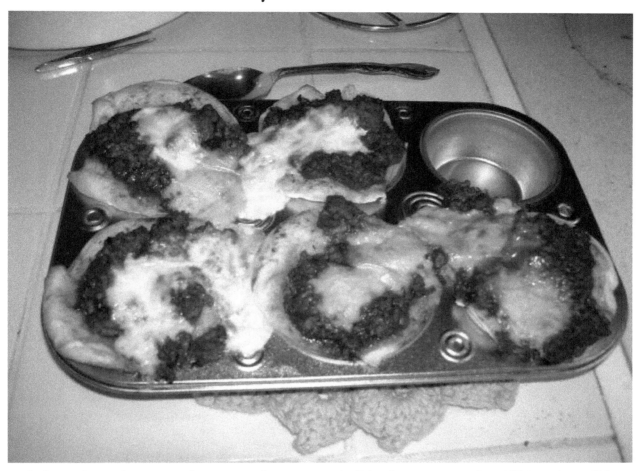

If your kids are demanding you only eat pizza for every meal of the day, give in to them! This recipe will have your whole house smelling like Italy, and your kids won't even notice that they're actually eating carrots.

**Servings: 12 muffins**
**Prep Time: 10 minutes**
**Cook Time: 18 minutes**
**Chilling Time: 0 minutes**
**Total Time: 28 minutes**

# Ingredients:

1 cup all-purpose flour
1 cup whole wheat flour
1 teaspoon baking powder
½ teaspoon baking soda
1 ½ cups milk
1 cup carrot, grated
1 cup shredded mozzarella cheese
¼ cup shredded parmesan cheese
¼ cup diced pepperoni
¼ cup olive oil or melted butter
2 eggs, beaten
2 teaspoons pizza seasoning
¼ teaspoon salt
¼ teaspoon pepper

## Instructions:

1. Preheat the oven to 375°F and grease a 12 count muffin tin with nonstick spray.
2. To a medium bowl, add the cheeses, milk, grated carrots, beaten eggs, and pepperonis (saving 2 tablespoons for topping). Mix together well.
3. Combine the flours, baking powder and soda, and seasonings in a separate bowl. Fold the dry into the wet until just combined.
4. Evenly spoon the mixture into the muffin tin (about ¼ cup per muffin). Top each muffin with the saved pepperonis.
5. Bake for 18-20 minutes or until a toothpick comes out cleanly.
6. Best served slightly warm with pizza sauce or ranch!

# Roasted Chickpeas

The perfect baggable snack, a crispy crouton alternative for soups and salads, and super healthy: roasted chickpeas are a tasty way for you kids to get introduced to the world of health benefits that legumes have to offer. If you don't like the sweet and slightly spicy curry flavor, try making these with an Italian herb blend like basil, oregano, and parsley. Paprika would give a beautiful color, wasabi powder would give a wicked kick, and lemon pepper chickpeas would be a perfect garnish to fish dishes. You could even try them as a sweet crunchy topping by roasting them with honey and rolling them in cinnamon sugar. The possibilities are endless, which is great because this low-effort recipe requires only a can of chickpeas, some pantry staples, and your imagination.

**Servings: 4 servings**
**Prep Time: 5 minutes**
**Cook Time: 30 minutes**
**Chilling Time: 0 minutes**
**Total Time: 35 minutes**

## Ingredients:

1 (14oz) can of chickpeas, drained
1 tablespoon olive oil
2 teaspoons mild curry powder (or any seasoning of your choice)

## Instructions:

1. Preheat the oven to 400°F and line a large baking sheet with parchment paper.
2. Drain the chickpeas and rinse them thoroughly with cold water, then pat dry with paper towels or a clean kitchen towel.
3. Remove any loose skins with your hands while you dry them.
4. To a mixing bowl, combine the chickpeas with the oil and seasoning. Mix together to ensure even coating.
5. Spread chickpeas across the prepared baking sheet and roast in the oven for 25-30 minutes, or until they are golden brown and crisped up.
6. Enjoy warm, or allow them to cool for easy storage at room temp. Don't refrigerate, as they'll lose their crunchy texture.

# Cheesy Zucchini Muffins

Super fresh and full of sweet summer veggies, these grab-and-go savory muffins complement any lunch and work as a refreshing breakfast as well. I found that the way to get my kids to love zucchini was through baking. The water content from the vegetable creates a super moist muffin or cake, and leaning into their slightly salty side with the cheese and onions creates the perfect bite.

**Servings: 12 muffins**
**Prep Time: 10 minutes**
**Cook Time: 20 minutes**
**Chilling Time: 0 minutes**
**Total Time: 30 minutes**

# Ingredients:

2 cups zucchini, grated
2 ½ cups all purpose flour
1 ½ cups milk
½ cup olive oil or melted butter
2 eggs, beaten
1 teaspoon baking powder
1 teaspoon salt
2 teaspoons sugar
1 cup grated cheddar cheese
½ cup crumbled feta cheese
2 tablespoons chives, chopped

# Instructions:

1. Preheat the oven to 390°F and grease a 12 count muffin tin with nonstick spray.
2. Whisk together the dry ingredients (flour, baking soda, salt, and sugar).
3. In a mixing cup or a separate bowl, mix together the wet ingredients (olive oil, milk, and eggs).
4. Pour the wet into the dry and fold together, folding in the grated zucchini, cheeses and chives as you go. Don't overmix.
5. Spoon batter evenly into muffin tin (about ¼ cup each) and bake for 15-20 minutes or until a toothpick comes out cleanly.
6. Serve warm with a side of red chili sauce. Enjoy!

All of these recipes are in your control. The basics are laid out in front of you, but you are more than welcome to customize the flavors any way that you'd like to suit your family. These were written to be kid-friendly, but you can make them more adult-friendly too! Add in some extra spice or some boozy cherries (just make sure to keep those separate from the ones going in the kids' lunchboxes!). Or, if you have a family of notoriously picky eaters, omit whatever is necessary. All that's important is that your household never goes hungry, and your kids will never have to turn to expensive, processed snacks again.

Now that we've got after school stuff covered, we're ready to move on to the more complicated (and more delicious) stuff. Pies are next, but they're grandma-approved to be forgiving, so don't stress too much about messing them up. There's nothing more euphoric than a pie cooling in the windowsill, the mouthwatering fruity smell filling your home for hours—flaky, buttery crusts, and a cold scoop of ice cream on the side. I bet you can taste it now...

# Chapter 3: Pies, Cobblers, and Tarts

Picture this: it's the late morning and the sun is beaming brightly through gossamer curtains, with a cool breeze drifting through. Your kitchen is warmed by the oven having been on, and your kids are just yawning awake. A beautiful, domed fruit pie steams on the windowsill; you're trying to get it cool enough for Saturday morning brunch.

Okay, so you don't have to be in this *exact* situation to make a pie, but doesn't it sound lovely?

Whether you're daring to brave making a full sized pie to feed a party, or a handful of tartlets for a glamorous after-dinner dessert, these recipes are a great place to start. If you've never baked a pie before, don't fret! These treats are quite forgiving, and you're sure to produce a product that everyone will love. Besides, if you ever get new neighbors, what kind of community member would you be if you didn't cheerily knock on their door to present them with a pie?!?

In the first recipe of this section, I've provided a basic recipe for pie dough. This stuff is quick to make and keeps forever in the fridge or freezer. If your dough is coming from the freezer, give it 15 minutes to come to room temp. There are so many variations of this staple, so if you find that experimenting with egg yolks in your dough creates a better final color, feel free to experiment! All of the recipes allocate enough time to whip up a batch, but if you're in a hurry, using the store-bought stuff is totally okay! If you use the premade crusts, about 30 minutes will be knocked off the final recipe time.

# All-American Apple Pie

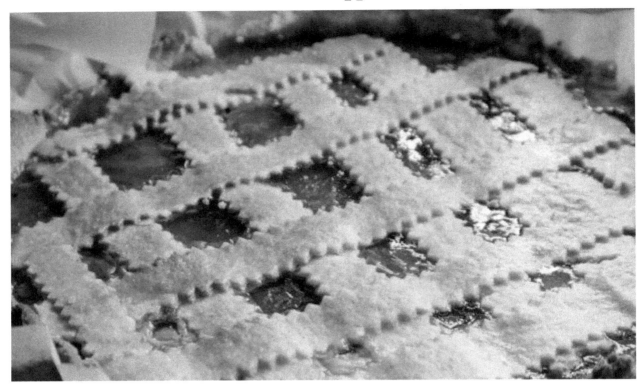

Name a dessert more classic than the apple pie—with its thick, soft apples coated in a luxurious sugary sauce, wrapped in a flaky, buttery lattice crust.

**Servings: 8 slices**
**Prep Time: 45 minutes**
**Cook Time: 50 minutes**
**Chilling Time: 30 minutes**
**Total Time: 2 hours 5 minutes**

# Ingredients:

**Pie Crust**

3 ½ cup all-purpose flour

1 cup + 4 tablespoons unsalted butter, chilled

¼ teaspoon salt

2 tablespoons white sugar

⅔ cup cold water (with more set aside if necessary)

**Filling**

8 cups peeled and sliced apples (5-6 large apples)

¼ cup apple juice or cider

2 tablespoons lemon juice

the zest of one lemon

¾ cup sugar

2 tablespoons all-purpose flour

2 tablespoons cornstarch

¼ teaspoon cinnamon

¼ teaspoon nutmeg

¼ teaspoon allspice

¼ teaspoon salt

2 tablespoons unsalted butter, cubed

**Egg Wash**

1 egg, beaten

1 tablespoon water

1 tablespoon sugar

1 tablespoon turbinado sugar

**Instructions:**

**Making the Crust**

1. In a medium bowl, mix together flour, sugar, and salt. Dice your cold butter into cubes and incorporate using your hands or a pastry blender. The dough should look like coarse sand.
2. Pour in the ice cold water a little at a time, mixing as you go with your hands, a fork, or the pastry blender, until dough just comes together.
3. Shape the dough into a ball and flatten into a piece of plastic wrap, wrapping tightly. Chill for 30 minutes in the fridge.

**Making the Filling**

1. Peel and slice all apples. In a large mixing bowl, combine the fruit, lemon juice and zest. In a smaller bowl, combine the sugar, flour, cornstarch, and all spices. Sprinkle mixture over the apples and stir. Pour over the apple juice or cider and allow the mixture to sit for 20 minutes.
2. Preheat the oven to 375°F and grease a 9 inch pie dish with nonstick spray.

**Assembly**

1. Once your dough is chilled, divide into two pieces, one slightly larger than the other. Using a lightly floured rolling pin, roll out the larger piece to about 13 inches in diameter, large enough to push down into the pie tin with about an inch hanging over the sides. Crimp the edges of the bottom pie crust by pinching and pushing the excess crust together, spinning the pie in one direction while you do so.
2. Roll out the other ball of dough into a slightly smaller circle (11 inches) and slice into ½ inch strips. Spoon your pie filling into the bottom crust so it makes a nice even mound. Taking your strips of pie dough, make a lattice in whatever pattern you like, by weaving the strips of dough together. Push the edges of the lattice into your crimped pie crust with a fork or your fingers.
3. Brush your egg wash over the lattice crust and the crimped edges, and sprinkle turbinado sugar on the pie for some extra sweetness and crunch.

4. Allow the pie to bake for 50 minutes. About 20 minutes in, if the crust is browning too quickly, cover with tin foil and continue baking until the filling is bubbling.
5. Serve warm or room temperature, with ice cream or without. Enjoy!

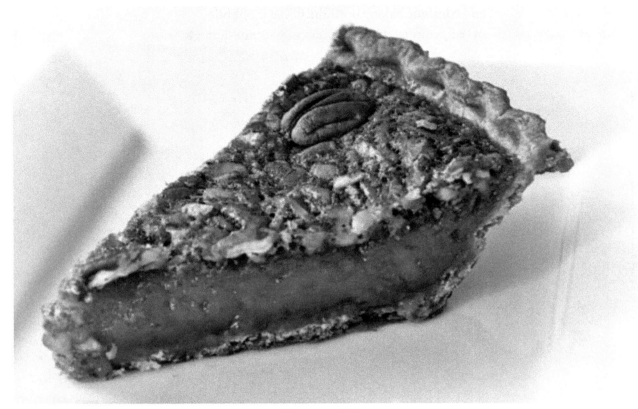

# Pecan Pie

**A caramely, sticky, and nutty concoction, this southern favorite is an instant** hit. Though the labor involved in making this pie might seem daunting, the sweet, thick syrup perfectly coating roasty-toasty pecan bits will be totally worth the effort.

The recipe is written to accommodate time to make your own pie crust (as written in the recipe prior), but if you use the store bought stuff or have some left from your last project, this recipe only takes about an hour.

**Servings: 8 slices**
**Prep Time: 45 minutes**
**Cook Time: 50 minutes**
**Chilling Time: 30 minutes**
**Total Time: 2 hours 5 minutes**

# Ingredients:

½ batch of pie dough
2 ½ cups shelled pecan halves
3 large eggs
1 cup dark corn syrup
½ cup packed brown sugar
¼ cup unsalted butter
1 ½ tablespoons vanilla
½ teaspoon salt
½ teaspoon cinnamon

**Egg Wash**
1 egg, beaten
1 tablespoon water
1 tablespoon sugar

## Instructions:

1. Preheat the oven to 350°F. Grease a 9 inch pie tin with nonstick spray. Roll out the dough until it's approximately 12 inches in diameter, press into the pie tin, and crimp the edges. Brush with egg wash.
2. Roughly chop the pecans and pour into the pie crust. In a medium bowl, whisk together the eggs, corn syrup, brown sugar, melted butter, vanilla, and spices. Pour over pecans, careful not to overflow the crust.
3. Bake for 5o minutes on the bottom rack. After 20 minutes, if browning too quickly, cover with aluminum foil and continue baking until the pie has set. Allow to cool at room temperature, where the pie will settle and solidify completely.
4. Serve warm or at room temperature. Leftovers will keep covered at room temp for 2 days, or longer in the fridge.

# Indiana Sugar Cream Pie

This might be the easiest pie ever, but it's still delicious. Only four ingredients make a creamy, melt in your mouth bite that will leave you in high heaven.

**Servings:** 8 slices
**Prep Time:** 45 minutes
**Cook Time:** 35 minutes
**Chilling Time:** 30 minutes
**Total Time:** 1 hour 50 minutes

# Ingredients:

½ batch pie dough
    1 cup white sugar
    2 cups whole milk
    ½ cup unsalted butter, cubed
    1 teaspoon vanilla
    1 teaspoon cinnamon

# Instructions:

1. Preheat the oven to 450°F and grease a 9 inch pie tin with non stick spray. Roll out pie crust to 12 inches in diameter, then press and crimp into pie dish. Fill with pie weights or dried beans/rice, and bake for 15 minutes. Remove pie weights (carefully) and bake for another 5 minutes until the crust is golden brown.
2. Reduce oven temperature to 375°F.
3. In a medium pot over medium heat, combine sugar and cornstarch and whisk in milk until mixture is smooth. Bring to a boil, whisking constantly to prevent scalding, then lower the heat slightly and allow to cook for 2 minutes or until mixture is very thick. Remove from the heat and whisk in cubed butter and vanilla. Pour into the crust and sprinkle with cinnamon.
4. Bake for 20 minutes and refrigerate for 30. Enjoy!

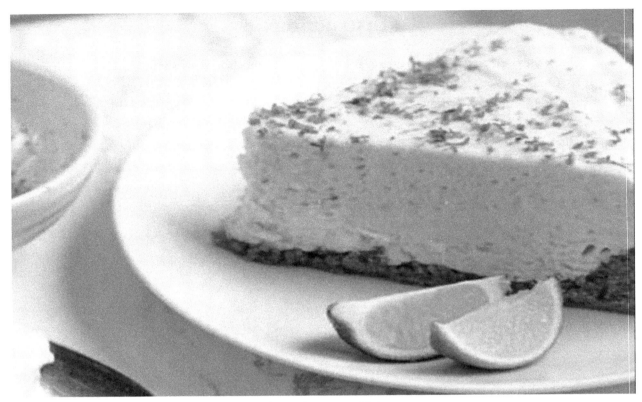

# Key Lime Pie

A refreshing summertime favorite! Though this recipe is made with the regular limes from the supermarket (which requires *much* less labor than juicing 20 tiny key limes), the taste isn't compromised at all. Besides, it's pretty hard to get your hands on key limes unless you live in the Florida Keys. I mean, I wish I did, but until I'm able to live out my retirement dreams in sunny Florida, I guess I'll survive by bringing the bright flavors to my own kitchen.

This pie uses a crumbly, buttery graham crust. I recommend putting your graham crackers in a gallon size ziploc and crushing them on the counter with a rolling pin, which is a great opportunity to release any pent-up stress. I top mine with fresh lime slices, but if you want to candy your lime slices, cook the thinly sliced limes in a cup of water and white sugar for about a half an hour, then allow them to cool and roll in more sugar. Though, this pie is perfectly sweet and tart already!

**Servings: 8 slices**
**Prep Time: 20 minutes**
**Cook Time: 25 minutes**
**Chilling Time: 3 hours**
**Total Time: 3 hours 45 minutes**

# Ingredients:

**Graham Cracker Crust**

    12 graham crackers, crushed

    ⅓ cup brown sugar

    6 tablespoons unsalted butter, melted

**Filling**

    1 cup plain greek yogurt

    Two 14oz cans of sweetened condensed milk

    ¾ cup fresh lime juice

    1 tablespoon lime zest

**Topping**

    1 cup heavy whipping cream, chilled

    2 tablespoons powdered sugar

    1 teaspoon lime zest

    8 thin slices of lime

## Instructions:

1. Preheat the oven to 375°F and grease a 9 inch pie tin with nonstick spray. In a medium bowl, mix together the graham cracker crumbs, brown sugar, and melted butter. Press mixture into the pie tin and up the sides with your fingers, then bake in the oven for 10 minutes.
2. In a large bowl, mix together ingredients for the filling. Lower oven temp to 350°F and pour the filling into the warm crust, then bake for 15 minutes until the filling is set, though it can still be slightly wobbly. Allow to cool in the refrigerator for 3 hours.
3. While pie is chilling, whip together topping with a hand or stand mixer until the consistency reaches stiff peaks. Pipe onto the chilled pie and garnish with sliced limes and more lime zest. Keep in the refrigerator.

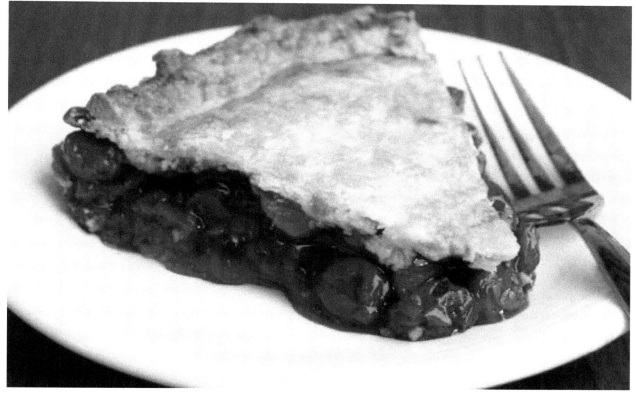

# Cherry Pie

A classic, sweet treat will satisfy any attendee at the pie social, this recipe pairs perfectly with a scoop of vanilla ice cream. Fresh cherries give the freshest flavor (no surprise there), but you can also use canned or frozen cherries, especially if you'd rather skip the labor of pitting your cherries. If you do brave the fresh route, but you don't have a cherry pitter laying around in a drawer (though it is a very useful tool, if you're planning to make this recipe more than one time or have any other need for pitted cherries, like toddlers who are at risk of choking—a cherry pitter will only cost you a couple bucks), you can use a chopstick or dowel to remove the pits efficiently.

If you want to use canned cherries, 4 cups drained will do (with ⅓ cup of the juice reserved). Frozen cherries should be thawed before use, then use them in the same way you would use the canned cherries.

**Servings: 8 slices**
**Prep Time: 45 minutes**
**Cook Time: 1 hour**
**Chilling Time: 2 hours**
**Total Time: 3 hours 45 minutes**

# Ingredients:

Full batch of pie dough (enough for top and bottom crusts)

4 ½ cup fresh cherries, pitted

¼ cup cornstarch

¾ cup white sugar

1 tablespoon lemon juice

1 teaspoon vanilla

¼ teaspoon almond extract

⅛ teaspoon salt

1 tablespoon unsalted butter, cubed

**Egg Wash**

1 egg, beaten

1 tablespoon water

1 tablespoon sugar

1 tablespoon turbinado sugar

# Instructions:

1. Preheat the oven to 400°F and grease a 9 inch pie tin with nonstick spray.
2. In a large bowl, mix together sugar, cornstarch, salt, almond and vanilla flavorings, and lemon juice. Add the cherries and coat them in the mixture. This will macerate the mixture, which means some liquid will be released. If you're using frozen or canned cherries, add in ⅓ cup of reserved juice. Allow to sit at room temp while you prepare the crust.
3. Roll out two sheets of pie dough, one slightly larger than the other (bottom crust about 12 inches, top crust about 11 inches in diameter). Leave about an inch hanging over the edge of the pie dish while you spoon in your filling, and sprinkle in the cubed butter.
4. Once the filling cas created a nice mounded shape, place the slightly smaller top crust in the center of the pie. Fold the overhang of the bottom crust over the top crust and crimp by pushing the crusts together between two fingers and pushing an indent into the crimp with a finger from the opposite hand while spinning the pie.
5. Whisk together egg wash and apply on the top crust and crimped edges with a pastry brush. Sprinkle turbinado sugar on top, cut a few slits in the top crust, and bake for 20 minutes, then reduce oven temp to 350°F and bake for 30-40 minutes longer or until the crust is bubbly and thick. If you're worried about the filling bubbling out and spilling, bake the pie on a baking sheet lined with tin foil.
6. Allow to cool for 2-3 hours so the filling can completely set, then enjoy!

# Whoopie Pies

These are more like cookies than they are pies, and they're very cake-like cookies... Whoopie Pies are a classic snack-cake-pie, perfectly balanced bites of chocolatey goodness and marshmallow cream.

**Servings: 16 pies**
**Prep Time: 30 minutes**
**Cook Time: 18 minutes**
**Chilling Time: 0 minutes**
**Total Time: 48 minutes**

# Ingredients:

2 cups all-purpose flour

½ cup unsweetened cocoa powder

1 cup packed brown sugar

½ buttermilk

½ cup neutral oil (like olive, avocado, coconut, or vegetable)

1 egg

½ cup hot water

1 teaspoon baking soda

1 ½ teaspoons vanilla

½ teaspoon salt

**Filling**

1 cup unsalted butter

2 ¼ cups powdered sugar

1 ½ cups (12 ounces) marshmallow fluff

1 teaspoon vanilla

## Instructions:

1. Preheat oven to 375°F and line two large baking sheets with parchment paper.
2. In a medium bowl, mix together dry ingredients (flour, cocoa powder, baking soda, and salt). In a larger bowl, whisk together oil, brown sugar, egg, buttermilk, and vanilla until very well blended. Pour dry ingredients into the wet, mix, then add the hot water and stir until combined.
3. Scoop 1 ½ tablespoons of batter onto prepared baking sheets, spacing about 2 inches apart.
4. Bake for 10 minutes, rotating trays halfway through, or until a toothpick comes out cleanly.
5. While they bake, whip together the filling using a hand or stand mixer. Cream together butter and powdered sugar first, then add in the vanilla, and finally fold in the marshmallow fluff.
6. Chill filling mixture while you wait for the cookies to bake and cool, and once completely cool, give the filling a quick mix before piping or spooning and smoothing onto half of the cookies, and finally sandwiching the Whoopie Pies together. They'll keep in the fridge for up to 3 days.

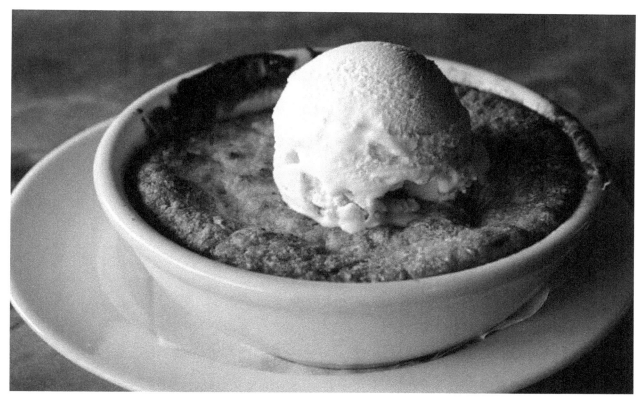

# Peach Cobbler

If you're looking for that gorgeous, summery peach flavor but don't feel like making a full-blown pie, cobbler is just as delicious and iconic, but half the work. Perfectly spongy and soft batter baked on top of nature's candy? Must be heaven.

**Servings: 9 servings**
**Prep Time: 15 minutes**
**Cook Time: 40 minutes**
**Chilling Time: 0 minutes**
**Total Time: 55 minutes**

## Ingredients:

1 cup all-purpose flour

    1 cup white sugar

    2 teaspoons baking powder

    ¼ teaspoon salt

    1 teaspoon cinnamon

    ¾ cup milk

    6 tablespoons unsalted butter

**Filling**

    4 cups peeled, sliced peaches

    ¾ cups white sugar

    ¼ teaspoon salt

**or**

    1 quart canned peaches, undrained

## Instructions:

1. Cook together the peaches, white sugar, and salt over medium heat in a saucepan until the peaches have released some liquid and softened a bit. If using canned peaches, skip this step.
2. Preheat the oven to 350°F and slice the butter into a 9x13 inch baking dish. Pop this into the oven while you prepare the batter. Once it's melted, take it out so it doesn't burn.
3. In a large bowl, mix together the flour, sugar, salt, and baking powder. Whisk in milk, but don't overmix. Pour this into your hot baking pan and spread evenly with a spatula. Pour peach mix overtop and spread, then sprinkle cinnamon. Bake for 40 minutes, and enjoy it warm.

# Blueberry Cobbler

Another fruit that tastes the freshest in the summer, blueberries are a tart variation of the previous cobbler.

**Servings: 6 servings**
**Prep Time: 15 minutes**
**Cook Time: 40 minutes**
**Chilling Time: 0 minutes**
**Total Time: 55 minutes**

# Ingredients:

⅔ cup all-purpose flour
½ cup white sugar
½ cup unsalted butter, softened
1 egg
¼ teaspoon baking powder
½ teaspoon vanilla extract
¼ teaspoon salt
**Filling**
3 cups fresh blueberries
3 tablespoons white sugar
⅓ cup orange juice

## Instructions:

1. Preheat the oven to 375°F. In an 8 inch square baking dish, mix together the filling and set aside to macerate.
2. In a medium bowl, mix together the flour, baking soda, and salt, and set aside.
3. With a hand or stand mixer, cream together the butter and sugar until fluffy, then mix in the egg and vanilla. Gradually add in the flour mixture until just combined. Pour the batter over the blueberry filling mixture, trying to cover as much of it as possible.
4. Bake for 40 minutes, or until the batter is golden brown, and enjoy it warm.

# Lemon Meringue Pie

This dairy-free dessert is still lush and creamy, packed with fresh lemon flavor that's sure to brighten your day.

**Servings: 8 slices**
**Prep Time: 30 minutes**
**Cook Time: 10 minutes**
**Chilling Time: 0 minutes**
**Total Time: 40 minutes**

## Ingredients:

**Filling**
    ½ batch pie crust
    1 cup white sugar
    2 tablespoons flour
    3 tablespoons cornstarch
    1 ½ cups water
    2 lemons, juiced and zested
    4 egg yolks
    2 tablespoons butter
    ¼ teaspoon salt

**Meringue**
    4 egg whites
    6 tablespoons white sugar

## Instructions:

1. Preheat the oven to 350°F and grease a 9 inch pie tin with nonstick spray. Roll out pie crust to 12 inches in diameter, then press and crimp into pie dish. Fill with pie weights or dried beans/rice, and bake for 15 minutes. Remove pie weights (carefully) and bake for another 5 minutes until the crust is golden brown.
2. In a medium saucepan over medium heat, whisk together the flour, sugar, cornstarch, and salt. Stir in water, lemon juice and zest. Bring to a boil, then stir in the butter. In a separate bowl, whisk together egg yolks and gradually whisk in ½ cup of the hot mixture to temper the eggs. Whisk the egg mixture back into the hot liquid and continue to boil until thickened. Remove from heat and pour into baked pie crust.
3. With a hand or stand mixer, whip together the egg whites, gradually adding in the 6 tablespoons of sugar until stiff peaks form. Spread meringue over the filling and bake in the oven for 10 minutes, or until the peaks of the meringue turn golden brown.
4. Store loosely wrapped with aluminum foil so moisture can escape.

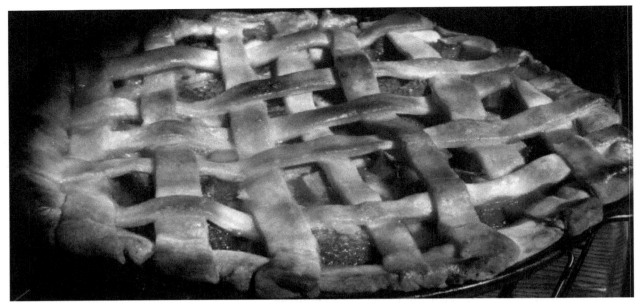

# Strawberry Rhubarb Pie

Rhubarb is a seriously underrated fruit, but it's one of my absolute favorites. Perfectly crisp and tart, it pairs perfectly with juicy, sweet strawberries. Paired with the flaky, chewy crust–this is my personal favorite pie. Trust me, you won't regret making it.

Rhubarb is best in spring; find stalks that are still firm, and just give them a good rinse, you don't need to peel them. You can use the frozen stuff if it's not in season, but you'll be able to find it at your local farmers market.

**Servings: 8 slices**
**Prep Time: 45 minutes**
**Cook Time: 50 minutes**
**Chilling Time: 0 minutes**
**Total Time: 1 hour 35 minutes**

# Ingredients:

Full batch of pie dough (enough for top and bottom crusts)
- 4 cups rhubarb, chopped
- 3 cups strawberries, quartered
- 2 large lemons, juiced and zested
- ½ cup white sugar
- ½ cup packed brown sugar
- 5 tablespoons cornstarch
- 2 teaspoons vanilla
- ¼ teaspoon salt

**Egg Wash**
- 1 egg, beaten
- 1 tablespoon water
- 1 tablespoon sugar
- 1 tablespoon turbinado sugar

## Instructions:

1. Preheat the oven to 350°F and grease a 9 inch pie tin with nonstick spray and roll out half of the pie dough t0 12 inches in diameter and push into your pie dish. Roll out the other ball of dough into a slightly smaller circle (11 inches) and slice into ½ inch strips.
2. In a large bowl, mix together all the ingredients for your filling.
3. Spoon your pie filling into the bottom crust so it makes a nice even mound. Taking your strips of pie dough, make a lattice in whatever pattern you like, by weaving the strips of dough together. Push the edges of the lattice into your crimped pie crust with a fork or your fingers.
4. Apply egg wash to the crust with a pastry brush and sprinkle turbinado sugar.
5. Bake for 50-55 minutes or until the filling is thick and bubbly and the crust is golden brown. Enjoy!

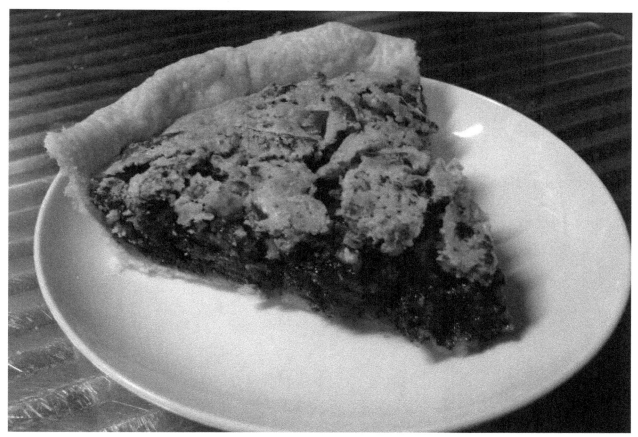

# Kentucky Chocolate Walnut Pie

This pie classically has a boozy kick (which mostly cooks out in the oven, but if you're worried about it, maybe keep this recipe for you and your partner). Whether or not you include the bourbon, this southern staple is delicious.

**Servings: 8 slices**
**Prep Time: 45 minutes**
**Cook Time: 40 minutes**
**Chilling Time: 3 hours**
**Total Time: 4 hours 25 minutes**

## Ingredients:

½ batch pie dough
    ½ cup white sugar
    ¾ cup corn syrup
    3 tablespoons unsalted butter
    3 eggs
    1 cup walnuts, chopped
    ¾ cup chocolate chips
    ¼ teaspoon salt
    2 tablespoons bourbon (optional)

# Instructions:

1. Preheat the oven to 375°F and grease a 9 inch pie tin with nonstick spray. Roll out pie dough to 12 inches in diameter and press into the tin, crimping the excess dough. Place the pie tin on a baking sheet.
2. In a medium bowl, whisk together all ingredients, folding in the chocolate chips and chopped walnuts.
3. Pour filling into the pie crust and bake in the oven on the baking sheet for 40 minutes, or until the middle has set.
4. Chill for at least 3 hours and serve with whipped cream.

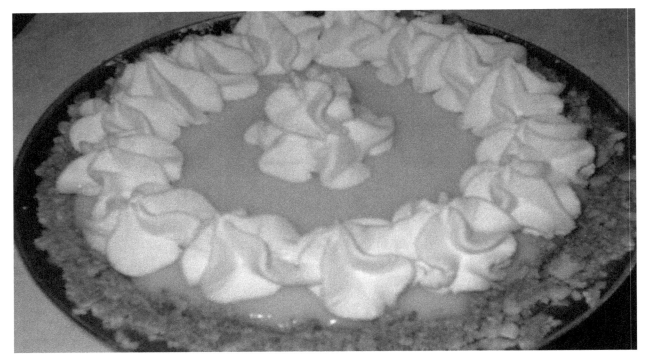

## Banana Cream Pie

If you've never had banana cream pie, let this be your chance. Full of rich, fibrous bananas, this pie is a huge kid-pleaser, and will get them their daily dose of potassium.

**Servings: 8 slices**
**Prep Time: 45 minutes**
**Cook Time: 15 minutes**
**Chilling Time: 1 hour**
**Total Time: 2 hours**

## Ingredients:

4 sliced bananas
½ batch pie dough
⅓ cup all-purpose flour
¾ cup white sugar
2 cups milk
3 egg yolks, beaten
2 tablespoons unsalted butter
1 ¼ teaspoons vanilla
¼ teaspoon salt

## Instructions:

1. Preheat the oven to 350°F and grease a 9 inch pie tin with nonstick spray. Roll out pie crust to 12 inches in diameter, then press and crimp into pie dish. Fill with pie weights or dried beans/rice, and bake for 15 minutes. Remove pie weights (carefully) and bake for another 5 minutes until the crust is golden brown. Allow to cool.
2. In a medium pot over medium heat, whisk together the flour, sugar, and salt. Slowly whisk in the milk a ½ cup at a time until all milk is added. Bring mixture to a boil and cook for 2 minutes, whisking constantly, until mixture has thickened.
3. In a smaller bowl, beat together the egg yolks. Whisk about a ½ cup of the hot mixture slowly into the yolks to temper them, then whisk them into the pot. Cook for 2 more minutes, then remove from the heat and add in the butter and vanilla.
4. Layer sliced bananas into the baked pie crust and pour the mixture on top. Bake for 12-15 minutes or until the custard has set.
5. Chill for an hour.

# Chocolate Chess Pie

**Servings: 8 slices**
    **Prep Time: 45 minutes**
    **Cook Time: 45 minutes**
    **Chilling Time: 0 minutes**
    **Total Time: 1 hour 30 minutes**

## Ingredients:

½ batch pie dough
    1 (5 oz) can evaporated milk
    1 ½ cups white sugar
    4 tablespoons cocoa powder
    3 tablespoons cornstarch
    2 large eggs, beaten
    4 tablespoons unsalted butter, melted
    1 teaspoon vanilla

## Instructions:

1. Preheat the oven to 350°F and grease a 9 inch pie tin with nonstick spray. Roll out pie dough to 12 inches in diameter, then lay and crimp into the dish. Set aside.
2. In a large bowl, whisk together all ingredients.
3. Pour mixture into prepared pie crust and bake for 45-50 minutes, or until a crackly crust has formed on top of the pie and the middle has mostly set.
4. Serve with whipped cream, if desired.

# Sweet Potato Pie

This is a dish you would feel good about taking to Thanksgiving dinner. This is a classic southern dish, and though it may seem similar to pumpkin pie, this recipe doesn't include any additional spices, just the pure, creamy sweet potato. If you want to add in a teaspoon of pumpkin pie spice or some cinnamon, feel free.

**Servings: 8 slices**
**Prep Time: 45 minutes**
**Cook Time: 1 hour 45 minutes**
**Chilling Time: 0 minutes**
**Total Time: 2 hours 30 minutes**

## Ingredients:

½ batch pie dough
3 medium sweet potatoes
½ cup milk
½ cup butter
1 cup white sugar
2 large eggs, beaten
2 teaspoons vanilla

## Instructions:

1. Preheat the oven to 450°F and bake your sweet potatoes on a baking sheet for 45 minutes, or until a fork can puncture it easily. Peel and mash them. Lower the oven to 350°F.
2. Grease a 9 inch pie tin with nonstick spray. Roll out pie dough to 12 inches in diameter, then lay and crimp into the dish.
3. Mash butter and milk into the sweet potatoes, then add in the rest of the filling ingredients and stir until smooth.
4. Bake for one hour, or until the center of the pie has set. Allow to cool slightly, and top with whipped cream or marshmallow fluff.

# Fresh Strawberry Pie

This is basically a transformed version of a strawberry shortcake, with a sweet, sticky glaze and the perfect bite of ripe strawberries (which are in season in the summertime). And, in the hot summertime, you won't need to keep the oven on for hours, because the crust is the only baked item in the recipe. However, it does need to be chilled for a while, so plan to make this the day before.

**Servings:** 8 slices
**Prep Time:** 45 minutes
**Cook Time:** 20 minutes
**Chilling Time:** 3 hours
**Total Time:** 4 hours 5 minutes

## Ingredients:

½ batch pie dough
4 cups fresh strawberries, sliced
¾ cup sugar
1 cup water
2 tablespoons cornstarch
1 (3 oz) package strawberry jello mix

## Instructions:

1. Preheat the oven to 350°F and grease a 9 inch pie tin with nonstick spray. Roll out pie crust to 12 inches in diameter, then press and crimp into pie dish. Fill with pie weights or dried beans/rice, and bake for 15 minutes. Remove pie weights (carefully) and bake for another 5 minutes until the crust is golden brown. Allow to cool.
2. In a small saucepan over medium heat, whisk together water, sugar, and cornstarch. Bring to a boil and continue to whisk until mixture has thickened.
3. Remove from the heat and stir in the strawberry jello. Allow the mixture to cool for 15 minutes.
4. Place sliced strawberries in the bottom of the baked pie crust and carefully pour the cooled mixture on top. Allow to chill in the refrigerator for at least 3 hours, or overnight.
5. Top with whipped cream if desired.

## Banoffee Pie

A classic English dessert, this might be a pie you've never tried before, but it's a delightful treat. Heath candy works great as the toffee bits.

**Servings: 8 slices**
**Prep Time: 25 minutes**
**Cook Time: 10 minutes**
**Chilling Time: 1 hour**
**Total Time: 1 hour 35 minutes**

# Ingredients:

**Graham Cracker Crust**

12 graham crackers, crushed

⅓ cup brown sugar

6 tablespoons unsalted butter, melted

**Filling**

3 large bananas, sliced

2 cups (16 oz) dulce de leche, with ¼ cup divided

½ cup toffee bits

**Topping**

1 pint heavy whipping cream

3 tablespoons white sugar

½ teaspoon vanilla

## Instructions:

1. Preheat the oven to 375°F and grease a 9 inch pie tin with nonstick spray. In a medium bowl, mix together the graham cracker crumbs, brown sugar, and melted butter. Press mixture into the pie tin and up the sides with your fingers, then bake in the oven for 10 minutes.
2. Pour 1 ½ cups dulce de leche into the pie crust. Layer in sliced bananas, saving some for garnish. Sprinkle the toffee bits on top. Drizzle on the remaining ¼ cup dulce de leche, making sure that all bananas are coated.
3. With a hand or stand mixer, whip together the heavy cream and sugar. Once stiff peaks form, stir in vanilla. Spoon whipped cream onto the pie and smooth.
4. Refrigerate for 1-3 hours, or overnight.
5. Top with bananas and toffee pieces, slice, and enjoy.

## Blackberry Pear Pie

Rustic and charming, this flavor combo will make you feel like you've just gotten back from your summer crop gathering. However, if it's not summertime when you get the hankering for this pie, substituting frozen or canned blackberries will do perfectly, though I would recommend trying to get fresh pears so the filling doesn't get too mushy.

**Servings: 8 slices**
**Prep Time: 45 minutes**
**Cook Time: 40 minutes**
**Chilling Time: 50 minutes**
**Total Time: 2 hours 15 minutes**

## Ingredients:

Full batch of pie dough (enough for top and bottom crusts)
    4 cups blackberries
    1 cup pear, diced finely
    1 cup white sugar
    4 tablespoons cornstarch
    1 lemon, juiced and zested
    1 tablespoon unsalted butter, cubed
    ¼ teaspoon salt

**Egg Wash**
1 egg, beaten
1 tablespoon water
1 tablespoon sugar
1 tablespoon turbinado sugar

# Instructions:

1. Preheat the oven to 425°F and grease a 9 inch pie tin with nonstick spray.
2. In a small bowl, combine sugar, lemon zest, cornstarch, and salt.
3. Roll out two sheets of pie dough, one slightly larger than the other (bottom crust about 12 inches, top crust about 11 inches in diameter). Lay in the bottom crust, leaving about an inch hanging over the edge of the pie dish. Pour in fruit, lemon juice, and sprinkle in the sugar mixture, stirring gently to combine. Top with the cubed butter.
4. Place the slightly smaller top crust in the center of the pie. Fold the overhang of the bottom crust over the top crust and crimp by pushing the crusts together between two fingers and pushing an indent into the crimp with a finger from the opposite hand while spinning the pie.
5. Chill pie in the refrigerator for 20 minutes.
6. Once chilled, whisk together egg wash and apply on the top crust and crimped edges with a pastry brush. Sprinkle turbinado sugar on top, cut a few slits in the top crust, and bake for 20 minutes, then reduce oven temp to 375°F and bake for about 20 minutes longer or until the crust is bubbly and thick. If you're worried about the filling bubbling up and spilling, bake the pie on a baking sheet lined with tin foil.
7. Chill for at least 30 minutes before serving.

# Rocky Road Pie

Yes, just like the ice cream, this pie is the perfect balance of salty, sweet, fluffy goodness!

**Servings:** 8 slices
**Prep Time:** 30 minutes
**Cook Time:** 10 minutes
**Chilling Time:** 3 hours
**Total Time:** 3 hours 40 minutes

# Ingredients:

**Crust**

10 chocolate graham crackers, crushed

¼ cup salted, roasted peanuts, crushed

½ cup unsalted butter, melted

**Filling**

1 cup mini marshmallows

1 cup semi sweet chocolate chips or chopped chocolate

2 cups whole milk ricotta, room temp

¼ teaspoon salt

½ teaspoon vanilla

**Topping**

1 cup heavy whipping cream

1 tablespoon white sugar

¼ teaspoon vanilla

chopped peanuts, chocolate, and mini marshmallows for garnish

## Instructions:

1. Preheat the oven to 375°F and grease a 9 inch pie tin with nonstick spray. Crush chocolate graham crackers and peanuts in a gallon ziploc bag or in a food processor, then stir or blitz in butter. Press mixture into the pie tin and up the sides with your fingers, then bake in the oven for 10 minutes. Allow to cool.
2. Melt the chocolate. If you have a microwave, melt the chocolate in a microwave-safe bowl over medium power in 1 minute increments, mixing in between. Once chocolate is 75% melted, stir vigorously until smooth. If you don't have a microwave, use the double boiler technique. In a medium sized pot, heat about an inch of water to a simmer. Choose a glass or metal bowl, shallow enough so the bottom of it doesn't touch the water. Add chocolate and stir constantly until chocolate is 75% melted. Turn off heat and mix vigorously until smooth.
3. With a hand or stand mixer, (or in a food processor) mix ricotta until most of the lumps are gone. Drizzle in the melted chocolate, vanilla, and salt. Mix until smooth, then fold in the marshmallows.
4. Spoon mixture into the cooled crust, smooth, and refrigerate for at least 3 hours, or overnight.
5. While chilling, using a hand or stand mixer, whip together the heavy cream and sugar until stiff peaks form. Stir in vanilla, and spread over the completely chilled pie. Top with chopped peanuts, chocolate, and marshmallows. Keep in the fridge.

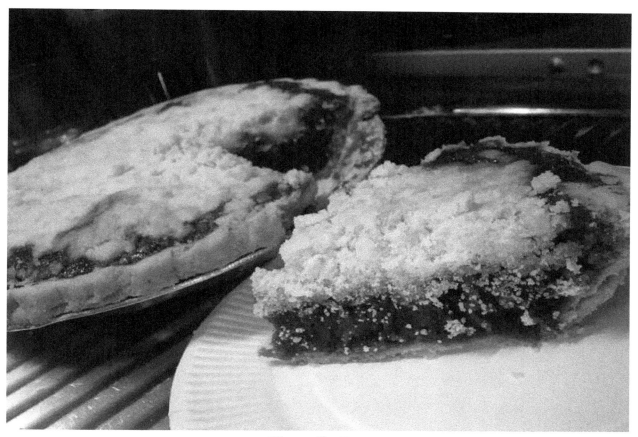

## Shoofly Pie

No one can resist a golden brown crumble topping, especially not when it's layered over a melty, caramelized filling.

**Servings: 8 slices**
**Prep Time: 45 minutes**
**Cook Time: 35 minutes**
**Chilling Time: 0 minutes**
**Total Time: 1 hour 20 minutes**

# Ingredients:

½ batch pie dough
¾ cup molasses
¾ cup boiling water
½ teaspoon baking soda
**Topping**
½ cups flour
½ cup brown sugar
1 teaspoon cinnamon
½ teaspoon nutmeg
¼ teaspoon salt
½ cup unsalted butter, chilled

## Instructions:

1. Preheat the oven to 450°F and grease a 9 inch pie tin with nonstick spray. Roll out pie crust to 12 inches in diameter, then press and crimp into pie dish.
2. In a medium bowl, make crumble topping by mixing together the dry ingredients and incorporating the butter using a pastry blender or your hands until loose crumbs form.
3. In a medium bowl, combine molasses, boiling water and baking soda and pour mixture into the baked pie crust. Spoon on the crumble topping and bake for 15 minutes, then lower the temperature to 350°F and bake for 20 minutes longer, until the pie is firm.

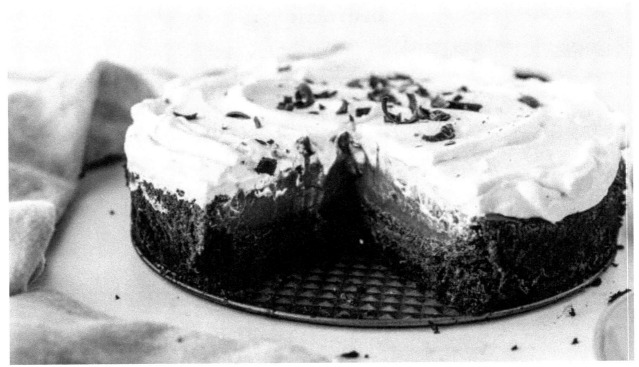

# Mississippi Mud Pie

Ths silky smooth pie is a chocolate lovers' dream! Perfectly light and creamy, with an irresistible velvety texture, this decadent three layer chocolate pie is sure to be a show-stopper.

**Servings:** 8 slices
**Prep Time:** 25 minutes
**Cook Time:** 50 minutes
**Chilling Time:** 5 hours
**Total Time:** 6 hours 15 minutes

# Ingredients:

**Graham Cracker Crust**

12 graham crackers, crushed

⅓ cup brown sugar

6 tablespoons unsalted butter, melted

**Brownie Filling**

¾ cup semi sweet chocolate chips or chopped chocolate

⅓ cup cocoa powder

½ cup white sugar

⅓ cup brown sugar

¼ cup all-purpose flour

½ cup unsalted butter, cubed

3 large eggs, separated

1 teaspoon vanilla extract

¾ teaspoon salt

**Chocolate Custard Filling**

1/2 cup semi sweet chocolate chips or chopped chocolate

¼ cup cocoa powder

½ cup white sugar

½ cup cornstarch

2 tablespoons unsalted butter, cubed

4 egg yolks

2 cups whole milk

¼ teaspoon salt

**Topping**

1 ½ cup heavy whipping cream

1 tablespoon white sugar

½ teaspoon vanilla

# Instructions:

1. Preheat the oven to 325°F and grease a 9 inch pie tin with nonstick spray. In a medium bowl, mix together the graham cracker crumbs, brown sugar, and melted butter. Press mixture into the pie tin and up the sides with your fingers, then bake in the oven for 10 minutes. If the crust isn't all the way done, that's okay: it'll have time to finish in the oven in the next step. Increase the oven temp to 350°F.

2. For the **Brownie Filling**, melt the chocolate with the cubed butter. If you have a microwave, melt the ingredients in a microwave-safe bowl over medium power in 1 minute increments, mixing between. Once chocolate is 75% melted, stir vigorously until smooth. If you don't have a microwave, use the double boiler technique. In a medium sized pot, heat about an inch of water to a simmer. Choose a glass or metal bowl, shallow enough so the bottom of it doesn't touch the water. Add chocolate and stir constantly until chocolate is 75% melted. Turn off heat and mix vigorously until smooth.

3. Remove from the heat and transfer to a bigger bowl if necessary. Whisk in the brown sugar, cocoa powder, salt, and vanilla. Allow to cool for a few minutes, then whisk in the 3 large egg yolks. With a hand or stand mixer, whip egg whites with the white sugar until stiff peaks form. Fold the egg white mixture into the chocolate base with a rubber spatula. Fold in the flour.

4. Transfer to the prepared crust and bake for about 30-35 minutes, or until only moist crumbs stick to a toothpick and a crust has formed over the top. Allow the cake to cool completely, at least an hour.

5. While the cake is chilling, prepare the **Chocolate Custard Filling**. In a medium saucepan over medium heat, whisk together the sugar, cocoa powder, cornstarch, and salt. Whisk in the milk a ¼ cup at a time, then whisk in the 4 egg yolks. Once boiling, cook until mixture has thickened. You can push the custard through a sieve at this point if a smoother texture is desired. Whisk in the chocolate and cubed butter until smooth. Pour custard on to the cooled cake and cover with plastic wrap, making sure to push it onto the surface of the custard so a skein doesn't form. Refrigerate at least 4 hours, or overnight.

6. Before serving, whip together heavy cream and sugar with a hand or stand mixer until medium peaks form, then stir in vanilla. Dollop onto the top of the pie and dust with cocoa powder and chopped chocolate. Keep in the refrigerator and enjoy!

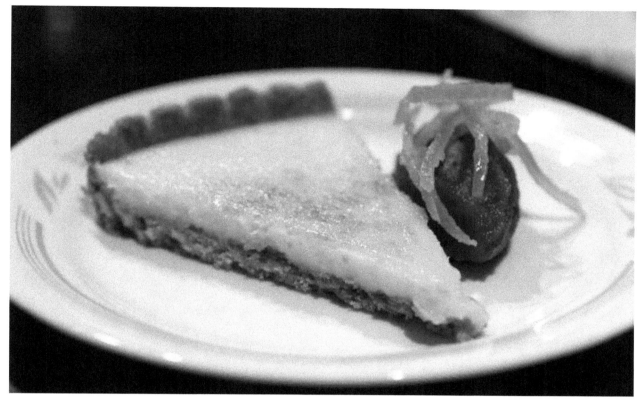

# Lemon Tart

There seriously might not be anything more delightful than lemon curd, and paring that with a buttery crust? So. Good. Top this treat with any fresh fruit of your choosing, candied lemons, or whipped cream.

**Servings: 12 slices**
**Prep Time: 45 minutes**
**Cook Time: 15 minutes**
**Chilling Time: 1 hour**
**Total Time: 2 hours**

# Ingredients:

½ batch pie dough

2 lemons, juiced and zested (½ cup juice and 1 ½ tablespoons zest)

¾ cup white sugar

1 ¼ cup unsalted butter, cubed

3 eggs + 3 egg yolks

# Instructions:

1. Preheat the oven to 350°F and grease a 9 inch tart shell with nonstick spray. Roll out pie crust to 12 inches in diameter, then press into tart shell and trim the sides with a knife, leaving a tiny bit of overhang so the crust will stay tall in the shell. Fill with pie weights or dried beans/rice, and bake for 15 minutes. Remove pie weights (carefully) and bake for another 5 minutes until the crust is golden brown. Allow to cool completely.
2. In a medium saucepan over medium heat, whisk together all ingredients. Whisk constantly, especially while the butter melts, to emulsify the mixture. Cook until mixture is quite thick, or stable enough to hold its shape when dolloped. This should take about 5-8 minutes.
3. Push mixture through a fine mesh sieve to remove any clumps.
4. Pour into a tart shell and smooth using a spatula. Bake at 350°F for 5 minutes. It won't be completely set, but shouldn't be liquidy.
5. Allow the tart to fully cool before slicing, an hour or longer.

# Salted Chocolate Tart

Servings: 12 slices
Prep Time: 45 minutes
Cook Time: 50 minutes
Chilling Time: 1 hour
Total Time: 2 hours 35 minutes

## Ingredients:

½ batch pie dough
    1 cup heavy cream
    ½ cup milk
    2 large eggs, beaten
    1 cup semi sweet chocolate chips or chopped chocolate
    2 tablespoons white sugar
    ¼ teaspoon salt

## Instructions:

1. Preheat the oven to 350°F and grease a 9 inch tart shell with nonstick spray. Roll out pie crust to 12 inches in diameter, then press into tart shell and trim the sides with a knife, leaving a tiny bit of overhang so the crust will stay tall in the shell. Fill with pie weights or dried beans/rice, and bake for 15 minutes. Remove pie weights (carefully) and bake for another 5 minutes until the crust is golden brown. Allow to cool completely. Reduce oven temp to 325°F.
2. In a medium pot over medium heat, heat the cream and milk until simmering, making sure to whisk constantly to prevent scalding. Remove from the heat and whisk in the chocolate until smooth. Add in sugar, salt, and beaten eggs and stir until completely combined.
3. Bake for 15-20 minutes until the filling has set. If any bubbles or cracks form, that means the tart is becoming overbaked and you should take it out.
4. Allow to cool before slicing, at least an hour.

# Salted Maple Apple Tarte Tatin

For this recipe, definitely invest in a high quality brand of maple syrup (the real deal), not the cheap, thin stuff that you'd throw on pancakes. Trust me, it really makes a difference.

**Servings:** 8 slices
**Prep Time:** 45 minutes
**Cook Time:** 40 minutes
**Chilling Time:** 15 minutes
**Total Time:** 1 hour 40 minutes

## Ingredients:

½ batch pie dough

8 cups apples, sliced into thin rounds, cored and seeded (5-6 apples)
1 cup unsalted butter
½ cup maple syrup
1 teaspoon vanilla
¼ teaspoon salt

**Topping**
½ cup pepitas
1 tablespoon unsalted butter
1 tablespoon maple syrup
½ teaspoon cinnamon
⅛ teaspoon salt

# Instructions:

1. Preheat the oven to 425°F.
2. In a wide, oven safe skillet (like cast iron, or a 12 inch oven safe nonstick pan), bring the butter and maple syrup to a boil on the stove. Cook for about 2 minutes, then add the apple slices in as evenly as you can. If it seems like they won't all fit, don't fear, they'll cook down. Cook for 10 minutes, stirring frequently. Remove from the heat, stir in the vanilla, and arrange the apples evenly on the bottom of the skillet.
3. Roll out your pie dough to 12 inches in diameter and place the sheet of dough over the apples, pressing and tucking the pastry into the sides of the dish. Cut slits in the top of the crust to vent. Place the skillet in the oven and bake for 30-35 minutes, or until the crust is golden brown and baked through.
4. While baking, prepare the topping. In a medium skillet over medium heat, cook together all ingredients, tossing regularly. This should take 3-5 minutes. Sprinkle with salt.
5. Once the tarte tatin has baked, allow to cool in the pan for at least 15 minutes. Then, use a paring knife to loosen up the edges of the dessert, and carefully invert onto a plate. Top with pepita mixture and serve warm.

# Fig and Plum Frangipane Tart

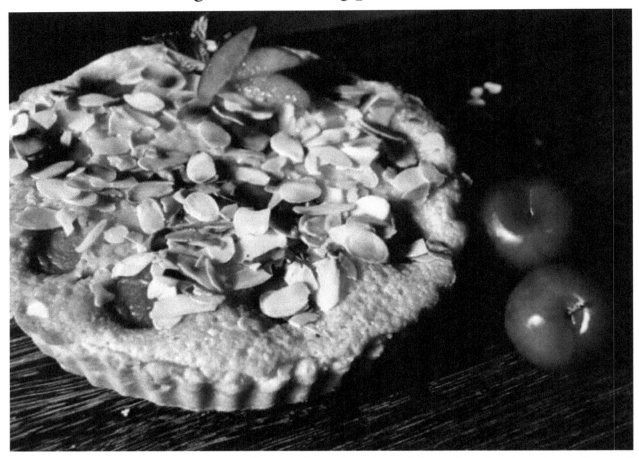

This dessert is meant to be a centerpiece. Elegantly layered wedges of fruit, glazed with a glossy glaze and dusted with powdered powdered sugar, this sophisticated tart has an awesome not-too-sweet flavor profile, and a huge amount of fiber. If you want to elevate this dish even more, try substituting rye flour for all-purpose flour and blending in some cinnamon and nutmeg into the pie dough.

**Servings: 8 slices**
**Prep Time: 45 minutes**
**Cook Time: 1 hour**
**Chilling Time: 2 hours**
**Total Time: 3 hours 45 minutes**

# Ingredients:

½ batch pie dough

**Filling**

6 plums, sliced

10-12 large figs, sliced

1 cup almond paste

½ cup unsalted butter, softened

3 tablespoons sugar

3 tablespoons all-purpose flour

2 large eggs

1 teaspoon vanilla

¼ teaspoon almond extract

1 teaspoon cinnamon

½ teaspoon star anise, ground

½ teaspoon nutmeg

½ teaspoon salt

2 tablespoons turbinado sugar

**Glaze**

⅓ cup plum or apricot preserves (if you can't find plum)

2 tablespoons water

1 tablespoon almond liqueur

2 tablespoons powdered sugar, for dusting

## Instructions:

1. Preheat the oven to 350°F and grease a 9 inch tart shell with nonstick spray. Roll out pie crust to 12 inches in diameter, then press into tart shell and trim the sides with a knife, leaving a tiny bit of overhang so the crust will stay tall in the shell. Fill with pie weights or dried beans/rice, and bake for 15 minutes. Remove pie weights (carefully) and bake for another 5 minutes until the crust is golden brown. Allow to cool completely. Increase oven temperature to 375°F.
2. With a hand or stand mixer, beat together the almond paste, softened butter, and sugar until well combined. Reduce speed and add in the eggs one at a time, then add in the vanilla and almond extract. With a rubber spatula, fold in flour, cinnamon, nutmeg, ground star anise, and salt. Spread this mixture evenly in the bottom of the baked tart shell.
3. Layer in sliced figs and plums (they should be sliced about ¼ inch thick). You can alternate figs and plums for a pretty design, but be careful not to push the fruit too deep into the filling. Sprinkle with turbinado sugar.
4. Bake for about an hour, or until the filling has puffed and gotten golden and the fruit is golden brown around the edges.
5. While the tart bakes, make the glaze by heating together the plum preserves and water. Stir in amaretto liqueur. Using a pastry brush, apply glaze to the top of the hot tart and then allow to cool for 2 hours.
6. Dust with powdered sugar, slice, and enjoy!

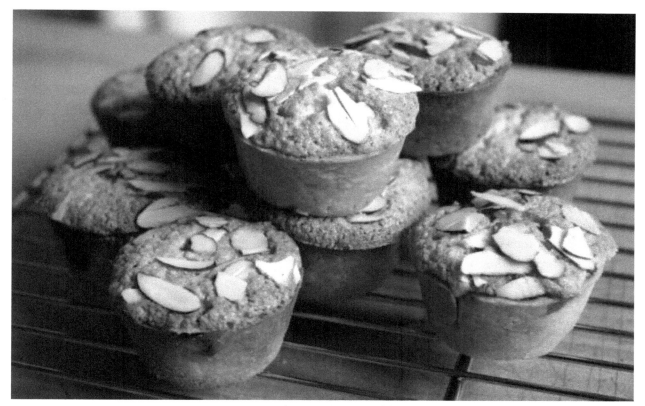

# Mini British Bakewell Tartlets

For this super cute recipe, you'll need some special cute tart pans. This recipe makes 6 tarts, and 4 inch mini tart pans are what you need.

**Servings:** 8 slices
**Prep Time:** 1 hour
**Cook Time:** 35 minutes
**Chilling Time:** 30 minutes
**Total Time:** 2 hours 5 minutes

# Ingredients:

Full batch pie dough

**Filling**

1 cup kirsch cherries, or fresh cherries soaked in Kirsch liqueur (or just fresh cherries with some cherry juice!)

1 cup fresh raspberries

¾ cup white sugar

1 tablespoon cornstarch

**Topping**

½ cup sliced almonds

1 cup almond flour

¼ cup all-purpose flour

½ cup unsalted butter, softened

½ cup white sugar

2 large eggs

¼ teaspoon almond extract

# Instructions:

1. Preheat the oven to 375°F. Roll out your pie dough into large sheets, and cut out circles an inch larger than the diameter of your mini tart tins. Grease the tins with a nonstick spray, and lay the dough circles into the tart pans, shaving any excess away with a paring knife. Allow for a tiny amount of overhang so the crust will stay tall in the shell, and prick the bottoms with a fork. Freeze the tarts for 15 minutes. Cover every tin with aluminum foil lining the crust. Bake in the oven for 12 minutes on a large baking sheet (this method blind bakes the crust without the help of pie weights).
2. After 15 minutes, carefully remove the foil and allow to bake uncovered for 3-5 minutes more, or until desired brownness has been reached. Allow to cool while you make the fillings. Lower the oven temperature to 350°F.
3. For the cherry jam, drain the cherries and reserve the juice. Chop the cherries and raspberries. In a small, separate bowl, mix together the cornstarch and 2 tablespoons of the juice. On the stove, heat the pot to medium heat, and pour in the cornstarch slurry, then stir in the sugar. Bring to a boil and allow to cook for 2 minutes, stirring frequently. The liquid should gelatinize. Try to break up the berries as best you can with a fork or a potato masher, and strain through a fine mesh sieve if you don't like the raspberry seeds. Set aside to cool.
4. Beat together the softened butter and sugar with a hand or stand mixer, then add in the eggs one at a time. Fold in the flours, slivered almonds, and almond extract.
5. Assemble the tarts by spreading the fruit jam on the bottom of each of the crusts. Top with the almond topping and spread evenly.
6. Bake for 10 minutes, then scatter more sliced almonds on top and bake for 10-12 more minutes, or until filling is golden brown and a toothpick comes out cleanly.
7. Allow to cool completely before dusting with powdered sugar.
8. Keep leftovers in the refrigerator.

Not so hard, right? Okay, some of these pie recipes required a labor of love and a LOT of patience, but if you were able to tackle even a couple of these recipes, you should be super proud of yourself.

Making homemade pie dough is a skill that you will remember for the rest of your life, and every time you do it, you'll get better. Practice makes perfect, so keep practicing, and keep experimenting! Did you discover that you love rhubarb and pears and are now dying to try out that combo? You now have the skills to do so.

# Chapter 4: Cookies and Bars

Now that you've mastered pies, you can relax with some easy cookie recipes. These are big batches made to be shared, so they're perfect to bring to a soccer game or bake sale. Seriously, everyone loves cookies. Making them homemade means they're cheaper, tastier, and the aromas can actually make you feel better.

My favorite recipe to make on a rainy day are the oatmeal raisin cookies. Perfectly soft and succulent, full of sweet raisins...they might not be everyone's favorite, but they bring me joy, so I make them. My kids, however, won't touch them, which means there's more for me.

I wonder which recipe will be your favorite?

## Refreshing Lemon Bars

If you loved that lemon tart a little too much, that might mean you're a secret lemon curd junkie, like I am, and no amount of lemon curd can satiate you. If so, this easy lemon bar recipe is for you, my friend.

**Servings: 36 bars**
**Prep Time: 15 minutes**
**Cook Time: 40 minutes**
**Chilling Time: 0 minutes**
**Total Time: 55 minutes**

# Ingredients:

**Crust**
- 2 cups flour
- ½ cup white sugar
- 1 cup unsalted butter, softened

**Filling**
- 2 lemons, juiced and zested
- ¼ cup all-purpose flour
- 1 ½ cups white sugar
- 4 eggs

## Instructions:

1. Preheat the oven to 350°F and prepare a 9x13 inch baking pan with parchment paper and nonstick spray, with parchment hanging off the shorter edges for easy removal.
2. In a medium bowl, combine all ingredients for the crust with your hands or a pastry blender and press into the bottom of the prepared pan.
3. Bake for 15-20 minutes or until flaky and golden. While baking, whisk together the sugar and flour for the filling. Then, whisk together the eggs, lemon juice and zest, and add into the dry ingredients. Mix well, and smooth over the baked crust.
4. Bake for 20 minutes, until bars have firmed up. Allow to cool before slicing, and dust with powdered sugar.

# Apple Crumble Bars

Servings: 9 bars
 Prep Time: 20 minutes
 Cook Time: 35 minutes
 Chilling Time: 0 minutes
 Total Time: 55 minutes

# Ingredients:

**Crust + Crumble Base**
- 2 cups all-purpose flour
- ½ cup white sugar
- ½ teaspoon baking powder
- ¼ teaspoon salt
- 1 cup unsalted butter
- 1 egg

**Crumble**
- ⅓ cup rolled oats

**Filling**
- 4 cups granny smith apples, diced
- ¼ cup all-purpose flour
- ¼ cup sugar
- ½ teaspoon cinnamon
- ¼ teaspoon nutmeg

## Instructions:

1. Preheat the oven to 350°F and grease an 8 inch square baking dish with parchment paper and nonstick spray, the parchment hanging off two edges for easy removal.
2. In a medium bowl, combine all ingredients for the base and mix together with your hands or a pastry blender, adding the egg in last. Press in ⅔ of the mixture into the bottom of the prepared pan, leaving the other ⅓ in the bowl.
3. Bake the crust for 15 minutes, then remove and allow to cool for at least 5 minutes.
4. While baking, mix in the oats to the remaining crust mixture to make the crumble topping and set aside.
5. Mix together all filling ingredients and spoon into the slightly cooled crust, smoothing to the edges. Use your hands to crumble the oat mixture on top, and spread.
6. Bake for 30-35 minutes or until the apples have softened and the top is deeply golden.
7. Slice and serve with caramel sauce and ice cream, if desired.

# Frosted Banana Bars

I seriously doubt that there's anything better in this world than cream cheese frosting. I would put it on everything if I could, so these banana bars are like heaven on a plate for me. With this naturally sweet banana cake smothered in the best frosting, there's not much more I could ask for.

**Servings: 24 bars**
**Prep Time: 15 minutes**
**Cook Time: 30 minutes**
**Chilling Time: 1 hour**
**Total Time: 1 hour 45 minutes**

# Ingredients:

1 ½ cups ripe bananas, mashed
2 cups all-purpose flour
2 cups white sugar
3 eggs
½ cup unsalted butter, softened
1 teaspoon baking soda
1 teaspoon vanilla
⅛ teaspoon salt

**Frosting**

1 cup (8oz) cream cheese, softened
½ cup unsalted butter, softened
4 cups powdered sugar
2 teaspoons vanilla

**Instructions:**

1. Preheat the oven to 350°F and grease a 9x13 baking pan with nonstick spray.
2. With a hand or stand mixer, cream together butter and sugar until fluffy (about 5 minutes). Beat in the eggs one at a time, then mix in the mashed bananas and vanilla. In a separate bowl, mix together the flour, baking soda, and salt, then stir into the mixture until the batter just comes together.
3. Pour batter into your prepared baking dish and bake for 25-30 minutes, or until a toothpick comes out cleanly from the center.
4. Allow to cool in the pan at room temp for at least an hour before frosting.
5. Just before frosting the cake, whip together the softened cream cheese and butter with a hand or stand mixer. Add in the powdered sugar a cup at a time and beat until smooth, then stir in vanilla.
6. Frost the bars with an offset spatula, and top with walnuts or any other topping of your choice.

# Pear Custard Bars

If you've never tried something like this before, you might be surprised by how good it actually is. Simple, with pears at the forefront, you can make this for any potluck and get raving reviews. And it can easily be made vegan by using shortening or vegan butter and replacing the egg with a flax egg.

**Servings: 16 bars**
**Prep Time: 30 minutes**
**Cook Time: 30 minutes**
**Chilling Time: 2 hours**
**Total Time: 3 hours**

# Ingredients:

**Crust**
    ¾ cup all-purpose flour
    ⅓ cup white sugar
    ½ cup unsalted butter, softened
    ⅔ cup macadamia nuts, chopped
    ¼ teaspoon vanilla

**Topping**
1 can pear halves, drained
1 cup (8oz) cream cheese, softened
½ cup white sugar + 1 tablespoon, divided
1 large egg
½ teaspoon vanilla
½ teaspoon cinnamon

## Instructions:

1. Preheat the oven to 350°F and grease an 8 inch square baking dish with nonstick spray.
2. With a hand or stand mixer, beat together butter and sugar until fluffy. Stir in vanilla. Add in flour gradually (¼ cup at a time) and stir in the macadamia nuts.
3. Press crust mixture into the prepared baking pan and bake for 20 minutes. Cool for at least 10 minutes at room temp. Increase oven temp to 375°F.
4. Slice pear halves into ⅛ inch slices and dry with paper towels. In a medium bowl, beat together cream cheese, sugar and vanilla. Add in the egg and beat until combined. Spread over the cooled crust and arrange pears on top. Sprinkle with an additional tablespoon of sugar.
5. Bake for 30 minutes. Filling may still jiggle. Cool in the pan on a wire rack before covering and transferring to the refrigerator. Allow to cool 2 hours before slicing.

## Tropical Pineapple Coconut Bars

A taste of the islands in your own kitchen, any time of the year. You can never go wrong with shortbread, and the toasty coconut on top is to die for.

**Servings: 16 bars**
**Prep Time: 20 minutes**
**Cook Time: 40 minutes**
**Chilling Time: 0 minutes**
**Total Time: 1 hour**

# Ingredients:

**Crust**
1 cup all-purpose flour
½ cup brown sugar
½ cup butter, softened

**Filling**
1 cup pineapple tidbits
1 cup shredded sweetened coconut
¼ cup all-purpose flour
⅓ cup brown sugar
2 eggs
1 tablespoon lime juice
1 tablespoon vanilla
¼ teaspoon salt

**Topping**
1 cup shredded sweetened coconut

## Instructions:

1. Preheat the oven to 350°F and grease a 10 inch square pan. Combine the crust ingredients in a medium bowl and press into the bottom of the pan. Bake for 12 minutes and allow to cool for 10 minutes.
2. In a medium bowl, combine the pineapple and coconut, and sprinkle on the flour, brown sugar, and salt. Stir to coat the fruit. Mix the eggs in one at a time, then add in the lime and vanilla flavorings. Pour the filling over the crust and spread evenly.
3. Top with remaining cup of coconut and bake for 25-28 minutes, or until coconut is toasted. Allow to cool slightly before slicing.

# Ultimate Fudgy Brownies

The debate of cakey versus fudgy brownies is put to rest with this recipe: fudgy all the way. You get that trademark crackly brownie crust and a warm, melty center. I definitely recommend using a double boiler for this recipe (not the microwave) because you'll get a better final texture.

**Servings: 16 bars**
**Prep Time: 15 minutes**
**Cook Time: 30 minutes**
**Chilling Time: 0 minutes**
**Total Time: 45 minutes**

## Ingredients:

½ cup all-purpose flour
1 ¼ cups white sugar
10 tablespoons unsalted butter
¾ cup cocoa powder
2 large eggs
1 teaspoon vanilla
⅛ teaspoon salt
⅔ cup chopped walnuts, optional

## Instructions:

1. Preheat the oven to 350°F and prepare an 8 inch square baking dish with parchment paper and nonstick spray, the parchment hanging off two edges for easy removal.
2. Over a double boiler, combine butter, sugar, cocoa powder, and salt in a glass or metal bowl. Stir occasionally until the butter has melted. Remove from the stove and allow to cool for 5 minutes. Stir in the vanilla, then add in the eggs, one at a time, mixing very well after each addition.
3. Once batter is blended, add the flour and beat the mixture with a wooden spoon constantly for 2 minutes, or use a hand mixer. If using nuts, stir them in now.
4. Spread the batter evenly in the pan, and bake for 20-25 minutes. A toothpick should come out of the center with only moist crumbs attached.
5. Cool completely before slicing.

## PB & J Blondies

An every-day kid classic has been elevated to adult level! That being said, your kids will probably be begging for this recipe after they get a taste. This is another recipe that can be customized a million different ways; blondies are an excellent blank palette for flavors. Caramel syrup and apple preserves, mango chutney and apricot puree, lemon curd and mint, whatever you want!

Servings: 16 bars
Prep Time: 15 minutes
Cook Time: 30 minutes
Chilling Time: 0 minutes
Total Time: 45 minutes

## Ingredients:

1 ¼ cups all-purpose flour
1 cup brown sugar, packed
½ cup unsalted butter
1 large egg
¼ cup creamy peanut butter
½ teaspoon baking powder
⅛ teaspoon salt
1 teaspoon vanilla

## Topping

⅓ cup strawberry, grape, or any jelly of your choice
⅓ cup creamy peanut butter

## Instructions:

1. Preheat the oven to 350°F and prepare an 8 inch square baking dish with parchment paper and nonstick spray, the parchment hanging off two edges for easy removal.
2. Over a double boiler or in the microwave (45-60 seconds on high power), melt together the butter and peanut butter until just melted. Set aside to cool for 5 minutes.
3. Add the brown sugar to the butter mixture and stir thoroughly. Add in the egg and vanilla and stir very well. Pour in the flour and baking powder and stir just until all of the dry ingredients are incorporated, but don't over mix.
4. Spread batter into the prepared pan evenly.
5. Slightly melt the peanut butter and jelly in separate small bowls, either by leaving them on the oven while it's preheating or by microwaving them for 15 seconds each.
6. Dollop the slightly warmed peanut butter and jelly into the blondie batter, and swirl with a knife. Try to just swirl the top.
7. Bake for 30-35 minutes until the top is set and a toothpick comes out of the center with only moist crumbs attached.
8. Allow to cool completely before removing and slicing

# The Best Chocolate Chip Cookies

Servings: 24 cookies
  Prep Time: 30 minutes
  Cook Time: 10 minutes
  Chilling Time: 30 minutes
  Total Time: 1 hour 10 minutes

# Ingredients:

2 ½ cups all-purpose flour
    ½ teaspoon baking soda
    1 teaspoon salt
    1 teaspoon vanilla
    1 cup butter, softened
    1 cup brown sugar, packed
    ½ cup white sugar
    2 eggs, room temperature
    2 cups semi-sweet chocolate chips or chunks

## Instructions:

1. With a hand or stand mixer, cream together the butter and sugars until just combined, it doesn't need to be fluffy. Beat in the eggs and vanilla. Stir together the flour and baking soda and incorporate it into the wet ingredients a little at a time until just incorporated. Fold in chocolate with a wooden spoon.
2. Wrap and chill the bowl in the freezer for 30 minutes.
3. Preheat the oven to 350°F while the dough is chilling. Line two cookie sheets with parchment paper and roll the dough into balls slightly smaller than golf balls. Place the balls about 2 inches apart so they have room to spread.
4. Bake for 10-12 minutes, and will be crispy on the edges but not quite set in the middle. Take the cookies out of the oven and let them cool on the cookie sheet for 5 minutes, before allowing them to cool on a wire rack completely.
5. Store in an airtight container at room temp for up to a week.

# Snickerdoodles

This is a genuinely quick recipe, for when you need an emergency batch of cookies.

**Servings: 24 cookies**
**Prep Time: 20 minutes**
**Cook Time: 10 minutes**
**Chilling Time: 0 minutes**
**Total Time: 30 minutes**

# Ingredients:

3 cups all-purpose flour
1 ⅓ cup white sugar
1 cup unsalted butter, softened
1 large egg + 1 egg yolk
2 teaspoons cream of tartar
1 teaspoon baking soda
½ teaspoon salt
1 ½ teaspoons cinnamon
2 teaspoons vanilla
**Topping**
⅓ cup white sugar
1 teaspoon cinnamon

## Instructions:

1. Preheat the oven to 375°F and line two cookie sheets with parchment paper.
2. In a medium bowl, combine the flour, baking soda, cream of tartar, salt, and cinnamon.
3. With a hand or stand mixer, beat together the butter and sugar until smooth. Add in the egg, the extra yolk, and vanilla. Beat until well combined. Add in the dry ingredients to the wet ⅓ cup at a time until just combined. The dough will be quite thick.
4. Roll the dough into balls slightly smaller than a golf ball (½ tablespoons). In a small, shallow container, combine the cinnamon and sugar for the topping and roll the dough balls in it before placing 2 inches apart on the cookie sheets.
5. Bake for 10 minutes; they'll be fluffy and soft. Allow cookies to cool for 10 minutes on the baking sheet and then transfer to a wire rack to cool completely.

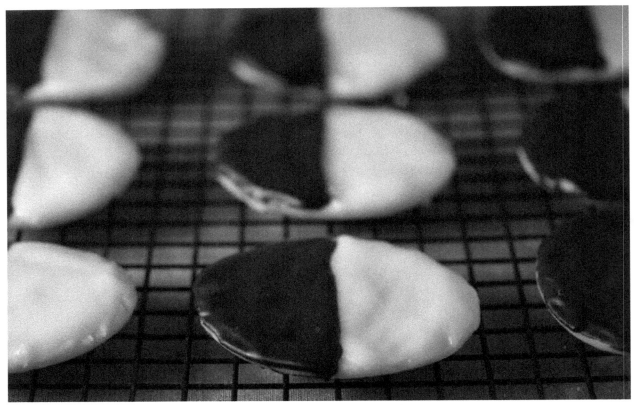

# Black and White Cookies

These New York staples are as striking and memorable as NYC itself. Delicious vanilla and dark chocolate glazes top a soft, cake-like cookie.

**Servings: 8 cookies**
**Prep Time: 20 minutes**
**Cook Time: 15 minutes**
**Chilling Time: 1 hour**
**Total Time: 1 hour 35 minutes**

# Ingredients:

1 ⅓ cups all-purpose flour
½ cup white sugar
½ teaspoon baking soda
½ teaspoon salt
1 large egg
⅓ cup buttermilk
6 tablespoons unsalted butter, softened
2 teaspoons vanilla

**Icing**

2 cups powdered sugar
2 tablespoons water, with more as needed
1 teaspoon corn syrup
½ teaspoon vanilla
3 tablespoons cocoa powder
2 teaspoons lemon juice, optional

## Instructions:

1. Preheat the oven to 350°F and line two cookie sheets with parchment paper.
2. Combine the flour, baking soda, and salt in a medium bowl and set aside.
3. With a hand or stand mixer, cream together the butter and sugar until fluffy. Beat in the egg and vanilla.
4. Alternate adding in the flour and buttermilk, ending with the flour. Mix until just combined. Scoop out just under ¼ cup of batter and place 4 inches apart on the baking sheets (4 cookies on one sheet, 5 on the other).
5. Bake for 13-15 minutes or until the centers are fully baked. Allow to cool for 5 minutes before transferring to a wire rack and cooling the cookies upside down. The bottom will become the flat top that you'll spread icing on. Cool the cookies for an hour, or until they're cool to the touch.
6. Right before icing, whisk together the powdered sugar, vanilla, corn syrup, and as much water as needed for a thin, glossy icing to a medium bowl. Transfer a little less than half of the icing to a smaller bowl and whisk in the cocoa powder. Add more water if necessary to match the texture of the white icing.
7. Dip all of the cookies in the vanilla icing. Allow to set completely. Use an offset spatula to cover half of the cookies with the chocolate icing.
8. Enjoy!

## Classic Peanut Butter Cookies

Servings: 24 cookies
Prep Time: 15 minutes
Cook Time: 10 minutes
Chilling Time: 1 hour
Total Time: 1 hour 25 minutes

## Ingredients:

1 cup white sugar
    1 cup brown sugar, packed
    1 cup unsalted butter, softened
    1 cup creamy or crunchy peanut butter
    2 large eggs
    2 ½ cups all-purpose flour
    1 ½ teaspoons baking soda
    1 teaspoon baking powder
    ½ teaspoon salt

## Instructions:

1. Preheat the oven to 375°F and grease two large cookie sheets with nonstick spray. In a medium bowl, cream together butter, peanut butter, and sugar until fluffy. Beat in the eggs one at a time.
2. In a separate bowl, sift together the flour, baking powder and soda, and salt, then incorporate into the butter mixture. Cover the bowl and refrigerate for 1 hour.
3. Roll dough into 1 inch balls and place on baking sheets an inch apart. Flatten each ball with a criss-crossed fork pattern.
4. Bake for 10 minutes until flattened and beginning to brown.
5. Serve and enjoy!

## Italian Rainbow Cookies

Servings: 35 cookies
Prep Time: 30 minutes
Cook Time: 10 minutes
Chilling Time: 5 hours
Total Time: 5 hours 40 minutes

## Ingredients:

2 cups all-purpose flour
1 cup white sugar
3 cups unsalted butter, softened and divided
1 cup (8 oz can) almond paste
4 eggs, separated
¼ cup milk
2 teaspoons almond extract
½ cup raspberry jam, divided
1 cup semi sweet chocolate chips, melted
¼ teaspoon red food coloring
¼ teaspoon green food coloring

## Instructions:

1. Preheat the oven to 325°F and prepare three 9x13 inch (quarter-inch thick) baking sheets with parchment paper and nonstick spray.
2. With a hand or stand mixer, cream together the sugar, one stick of butter, and almond paste. Mix until smooth, trying to break down the paste. Add in the remaining 2 sticks of butter and continue to mix until well incorporated.
3. Add in the egg yolks one at a time, then add in the milk and almond extract and mix well, scraping the bowl if needed. Add in the flour.
4. Clean your mixer and add in the egg whites, whipping until stiff peaks form. Fold the egg whites into the batter, then divide equally between 3 medium bowls.
5. Stir in a few drops of red food coloring at a time into the first bowl until desired color is reached. Do the same to the second bowl with the green food coloring, and leave the last bowl alone. Bake each color of batter in its own sheet tray for 10 minutes, rotating halfway through.
6. Allow to cool completely, then remove parchment paper. Once cooled, spread half of the raspberry jam on top of the green layer and sandwich the undyed layer on top. Spread the other half of the jam on top of that layer and place the red layer on top. Cover the cakes with plastic wrap and weigh down with plates or cans. Refrigerate for 4 hours, or overnight.
7. Melt chocolate using a double boiler or the microwave. Remove weights and plastic.
8. Spread melted chocolate over the top of the cake, and chill for another 30 minutes.
9. Once cooled, cut the cake into 1 ½ inch squares, and enjoy!

## Chewy Oatmeal Raisin Cookies

Though they might not be everyone's cup of tea, these cookies are my personal favorite. Thick, chewy, sugary oats with pockets of sweet and chewy raisins, these cookies are so pleasing to eat.

**Servings: 24 cookies**
**Prep Time: 15 minutes**
**Cook Time: 10 minutes**
**Chilling Time: 30 minutes**
**Total Time: 55 minutes**

## Ingredients:

1 cup all-purpose flour
    ½ teaspoon cinnamon
    ½ teaspoon baking soda
    ¼ teaspoon salt
    1 ½ cups rolled oats
    ½ cup brown sugar, packed
    ¼ cup white sugar
    ½ cup unsalted butter, softened
    1 large egg
    1 cup raisins
    1 teaspoon vanilla

# Instructions:

1. With a hand or stand mixer, beat together the butter, brown sugar, and white sugar for 2 minutes. Add in the egg and vanilla.
2. In a large bowl, mix together the flour, oats, cinnamon, baking soda, and salt.
3. Add the dry ingredients to the wet and mix until just combined. Fold in the raisins.
4. Cover the dough and refrigerate for 30 minutes
5. Preheat the oven to 350°F and line two cookie sheets with parchment paper.
6. Roll the dough into 1 ½ tablespoon balls and gently press them onto the prepared trays, about an inch apart from one another.
7. Bake for 10-12 minutes or until cookies are golden brown and set. Remove and cool for 5 minutes, then enjoy.

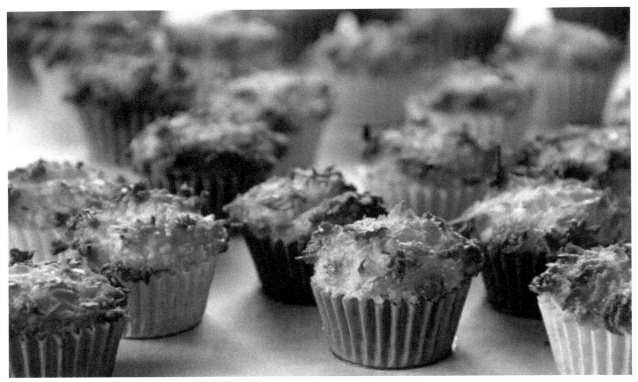

# Coconut Macaroons

If you're a coconut fiend, then there's nothing more delightful than a fluffy, sweet macaroon. Much easier than their french cousins (macrons), this dessert has only 6 ingredients.

**Servings: 26 macaroons**
**Prep Time: 20 minutes**
**Cook Time: 25 minutes**
**Chilling Time: 0 minutes**
**Total Time: 45 minutes**

## Ingredients:

1 ¾ cup sweetened shredded coconut
⅞ cup (7oz) sweetened condensed milk
2 large eggs, divided (you only need the whites, so you can save the yolks for another recipe)
1 teaspoon vanilla
¼ teaspoon salt
½ cup semi sweet chocolate chips or chunks, melted

# Instructions:

1. Preheat the oven to 325°F and line two cookie sheets with parchment paper.
2. In a medium bowl, stir together the coconut, sweetened condensed milk, and vanilla.
3. Using a hand or stand mixer, beat together the egg whites until stiff peaks form. Fold the egg whites into the coconut mixture with a rubber spatula.
4. Form heaping tablespoons of the mixture onto the baking sheets, about an inch apart. Bake for 25 minutes, rotating halfway through, until the edges are golden brown.
5. Allow to cool on a wire rack. While they cool, melt the chocolate over a double boiler or in the microwave. Dip the bottoms of the macaroons and drizzle more chocolate on top, if desired.
6. Allow the chocolate to set for 10 minutes in the fridge, then enjoy!

# Homemade Graham Crackers

If you're itching for a s'more or need to make a graham cracker crust but don't feel like going to the store, making them at home is surprisingly easier than you might think. Besides, when you make it yourself, you know exactly what's in it; no chemicals, no nonsense.

**Servings: 22 crackers**
**Prep Time: 30 minutes**
**Cook Time: 10 minutes**
**Chilling Time: 1 hour**
**Total Time: 1 hour 40 minutes**

## Ingredients:

2 cups whole wheat flour
1 cup brown sugar, packed
⅓ cup honey
7 tablespoons butter, softened
3 tablespoons milk
1 teaspoon baking soda
1 teaspoon vanilla
1 teaspoon cinnamon
¾ teaspoon salt

# Instructions:

1. Line two cookie sheets with parchment paper, and set aside.
2. In a large bowl, mix together the flour, sugar, cinnamon, baking soda, and salt. Add the butter in with your fingers or a pastry blender until the dough is crumbly.
3. In a separate bowl, whisk together the milk, honey, and vanilla. Stream in the milk mixture to the flour mixture and mix until a soft, sticky dough forms.
4. Wrap with plastic wrap and place in the refrigerator for at least an hour. Preheat the oven to 350°F.
5. Once chilled and able to work with, roll the dough out on a floured surface with a floured rolling pin. Using a pizza cutter or a chef's knife, cut the dough into rectangles, 2x5 inches. Score the cookies horizontally and vertically with the back of a knife, then prick the rectangles with a fork to make the classic pattern. Transfer the cookies to the prepared pans with a metal spatula.
6. Bake for 10-12 minutes or until they've reached desired crunchiness.

# Millionaire Shortbread

These are basically an upgraded version of a candy bar; therefore, your kids might become obsessed with them. Luckily, they're super easy to make and are sure to please any crowd.

**Servings: 20 bars**
**Prep Time: 20 minutes**
**Cook Time: 30 minutes**
**Chilling Time: 1 hour**
**Total Time: 1 hour 50 minutes**

# Ingredients:

**Crust**
- 1 cup all-purpose flour
- 2 teaspoons cornstarch
- ¼ teaspoon salt
- ¼ cup brown sugar
- 1 cup unsalted butter, chilled and cubed
- 1 large egg yolk
- 1 tablespoon water, chilled

**Caramel**
- 1 ¾ cup (14 oz) sweetened condensed milk
- ½ cup brown sugar
- 2 tablespoons golden syrup or corn syrup
- 6 tablespoons unsalted butter
- 1 teaspoon vanilla
- ¼ teaspoon salt

**Ganache**
- ¾ cup semi sweet chocolate chips or chunks
- 3 tablespoons heavy cream

## Instructions:

1. Preheat the oven to 350°F and line a 9 inch square baking pan with parchment paper overhanging two of the edges. Spray with nonstick spray and set aside.
2. Combine the flour, cornstarch, brown sugar, and salt very well. Incorporate the butter with your hands or a pastry blade until the mixture is very crumbly. Add in the egg yolk and stream in the water until the dough begins to clump together. Press into the prepared pan, and prick with a fork.
3. Bake for 20 minutes, or until golden and flaky, and allow to cool while you make the other components.
4. To make the caramel, whisk together the sweetened condensed milk, butter, brown sugar, golden or corn syrup, vanilla and salt in a medium pot. Bring to a boil, then allow to cook, stirring constantly, for about 6 minutes, or until the caramel has thickened considerably. If you have a candy thermometer, the temperature should be 225°F.
5. Pour the caramel over the slightly cooled crust and allow to cool for 15 minutes, or until the caramel is no longer runny.
6. Combine the chocolate and cream in a heat safe bowl and melt over a double boiler or in the microwave. Whisk very well, to incorporate some air, then spread over the caramel layer with a metal spatula. Refrigerate for at least an hour, then remove from the pan and cut.

# Red Velvet Cookies

Servings: 18 cookies
Prep Time: 10 minutes
Cook Time: 12 minutes
Chilling Time: 2 hours
Total Time: 2 hours 22 minutes

# Ingredients:

1 ½ cups + 1 tablespoon all-purpose flour
1 teaspoon baking powder
¼ teaspoon salt
¼ cup cocoa powder
¾ cup brown sugar
¼ cup white sugar
½ cup unsalted butter
1 large egg
1 tablespoon milk
2 teaspoons vanilla
½ teaspoon red gel food coloring (or ¾ teaspoon liquid dye)
1 cup white chocolate chips

# Instructions:

1. Prepare two large cookie sheets with parchment overhanging on two sides.
2. In a medium bowl, whisk together the flour, cocoa powder, salt, and baking soda.
3. Using a hand or stand mixer, beat together the butter, brown sugar, and white sugar until fluffy. Add in the egg, milk, and vanilla. Once mixed, add in the food coloring until a deep red color is reached. Pour in the dry ingredients to the wet and stir until just combined. Adjust color if necessary, then fold in the white chocolate chips.
4. Cover with plastic wrap and refrigerate for 2 hours, or overnight. If chilling overnight, allow to sit at room temp for 15 minutes otherwise the dough will be too hard.
5. Preheat the oven to 350° and roll into 1 ½ tablespoon balls. Bake 9 balls on each baking sheet, with enough room in between them to allow for spreading.
6. Cool cookies on the cookie sheets for 5 minutes, and once firm enough to transfer, finish cooling on a wire rack. Top the warm cookies with more white chocolate chips for a more aesthetic look.

# Cookie Pizza

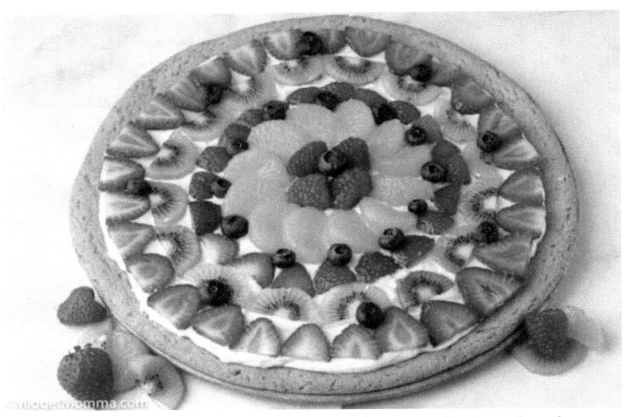

Perfect for a large party and only four ingredients, this pizza can be customized with any of your favorite toppings, like raspberry jam, whipped cream, and sprinkles; or hot fudge, crumbled graham crackers, and marshmallows. Or, if you're catering to picky eaters, you can keep it simple. This recipe uses store bought cookie dough, but if you want to make it from scratch, you know by now that it's not too hard. Just make sure to add in the extra bit of flour that this recipe calls for, so it stays stable.

**Servings:** 16 cookies
**Prep Time:** 15 minutes
**Cook Time:** 20 minutes
**Chilling Time:** 30 minutes
**Total Time:** 1 hour 5 minutes

## Ingredients:

1 (16.5oz) roll sugar cookie dough
¼ cup all-purpose flour
½ cup candy coated chocolates
¼ cup white chocolate chips

## Instructions:

1. Preheat the oven to 350°F, and prepare a 12 inch pizza pan with parchment paper and nonstick spray. You can also bake this in a 9x13 baking pan.
2. In a large bowl, break up the cookie dough and knead in the flour. Fold in ¼ of the chocolate candies and press the dough into the bottom of the pan. Arrange and press the remaining candies on top.
3. Bake for 16-20 minutes or until golden brown and set. Allow to cool for 30 minutes at room temp.
4. While it's cooling, melt the white chocolate chips over a double boiler or in the microwave. Spoon into a sandwich-sized plastic bag and seal, then snip off one corner. Drizzle the chocolate over the cookie, and allow it to sit for 10 more minutes so chocolate can set. Cut into wedges and serve.

# Double Ginger Cookies

Servings: 16 cookies
 Prep Time: 15 minutes
 Cook Time: 10 minutes
 Chilling Time: 0 minutes
 Total Time: 25 minutes

# Ingredients:

2 ¼ cups all-purpose flour
¾ cup white sugar
½ cup brown sugar, packed
2 tablespoons molasses
1 egg
¾ cup unsalted butter, softened
1 tablespoon milk
2 teaspoons baking powder
2 teaspoons ground ginger
½ teaspoon ground cinnamon
½ teaspoon salt
¼ cup candied ginger
1 teaspoon lemon zest

## Instructions:

1. Preheat the oven to 350°F and prepare two cookie sheets with parchment paper overhanging two sides and grease with nonstick spray.
2. In a medium bowl, stir together the flour, baking soda, salt, ground ginger, cinnamon, and candied ginger.
3. With a hand or stand mixer, cream together the butter, ½ cup of the white sugar, and the brown sugar until fluffy. Add in the molasses, lemon zest, and the egg. Alternate adding the flour mixture and the milk, starting and ending with the flour.
4. Place the remaining sugar in a shallow dish. Roll 1 tablespoon balls of the dough and roll in the sugar before spacing evenly on the baking sheets.
5. Bake for about 10 minutes or until the cookies begin to crack on the tops and edges have crisped.
6. Allow to cool on the baking sheet, then transfer to a wire rack.

# Chocolate Hazelnut Sandwich Cookies

Servings: 40 cookies
 Prep Time: 20 minutes
 Cook Time: 40 minutes
 Chilling Time: 1 hour
 Total Time: 2 hours

# Ingredients:

2 ¼ cup all-purpose flour
¾ cup sugar
¾ cup raw hazelnuts
2 cups + 6 tablespoons unsalted butter, softened
½ teaspoon cinnamon
⅛ teaspoon allspice
⅛ teaspoon salt
¼ cup semisweet chocolate chips or chunks
⅔ cup milk chocolate chips or chunks

# Instructions:

1. Preheat the oven to 325°F and roast ¼ cup of the hazelnuts in a pie tin or on a baking sheet for 15 minutes. Dump the hazelnuts onto a kitchen towel and rub the towel together to remove as many hazelnut skins as you can. Finely chop the nuts.
2. In a food processor or blender, grind the remaining ½ cup of hazelnuts with 2 tablespoons of white sugar. Add in the flour, spices, and the remaining sugar. Keep in the food processor or transfer to a bowl with a pastry blender if you were using an electric blender, and add in 2 cups of butter, mixing until a dough forms. Transfer the dough to a floured surface and knead 2-3 times. Shape the dough into two even disks, wrap in plastic wrap and chill for 30 minutes.
3. Prepare 2 large cookie sheets with parchment paper and nonstick spray. If you turned the oven off while the dough chilled, make sure it's set to 325°F.
4. Roll out one disk of dough to ¼ inch thick, and cut out disks with a cup or a 1 ½ inch cookie cutter. Arrange the cookies on the prepared sheets a ½ inch apart. Place in the oven and bake for 20 minutes. Do the same for the other half of the dough, and bake this sheet for 20 minutes after the first tray has come out of the oven. You can re-roll the scraps to make one more tray, but don't reuse the scraps after that.
5. Allow the cookies to cool on the baking sheet for a couple minutes, then transfer to a wire rack. While cooling, make the ganache. Over a double boiler, melt the chocolate with 6 tablespoons of butter, whisking until very smooth. Allow to cool for 10 minutes.
6. Flip half of the cookies so the flat bottoms become the tops. Spread a spoonful of the chocolate filling onto these cookies, leaving the other half of the batch to be the other half of the sandwich. Dip these cookies halfway into the ganache and sandwich them to the bottoms. Sprinkle the roasted chopped hazelnuts on top, and enjoy.

# Chapter 5: Classic Cakes

Birthday parties, weddings, and gender reveals: any cause for celebration could use a cake. There's nothing more classically comforting than the spongy crumb of a cake, paired with smooth, sweet frosting. Besides, who doesn't like cake?

    A reminder that although the total time for these recipes might seem long, a lot of it isn't active time; it's just the amount of time it takes to allow the cakes to cool enough to frost. If you're in a rush, you can pop the cakes covered into the fridge or freezer and you'll cut down your chilling time.

# The Best Vanilla Cake

You really can't go wrong here. An instant crowd pleaser, this recipe can easily be converted into cupcakes or have anything added into it. If you want your cake to be more white and less yellow, leave out the yolks of the eggs and replace with more egg whites and perhaps a dollop of yogurt for richness.

**Servings:** 12 slices
**Prep Time:** 35 minutes
**Cook Time:** 25 minutes
**Chilling Time:** 1 hour
**Total Time:** 2 hours

# Ingredients:

3 ⅔ cups cake flour

2 cups white sugar

1 ½ cups unsalted butter, softened

1 ½ cups milk

4 ¼ teaspoons baking powder

1 teaspoon salt

3 eggs + 2 egg whites

1 tablespoon vanilla

**Buttercream**

5 ½ cups powdered sugar

⅓ cup milk

1 ½ cups unsalted butter, softened

1 ½ teaspoons vanilla

⅛ teaspoon salt

# Instructions:

1. Preheat the oven to 350°F and line three 9 inch round cake pans with parchment paper cut to the size of the bottom of the tin, then grease with nonstick spray.
2. In a medium bowl, mix together the cake flour, baking powder, and salt.
3. Using a hand or stand mixer, whisk together the butter and sugar until light and fluffy (3-5 minutes). Add in the eggs and additional whites slowly, until all incorporated. Stir in the vanilla. Alternate adding in the dry ingredients and the milk, starting and ending with the dry mix. Don't overmix.
4. Evenly divide batter into the three cake tins (a little more than 2 ½ cups of batter per tin). Bake for 25 minutes, or until a toothpick comes out cleanly from the middle. Remove from the oven and cool in the pans until you can handle them, then turn the cakes out onto a wire rack and allow to cool completely, at least an hour.
5. When the cakes are done cooling, make the frosting. With a hand or stand mixer, beat the softened butter until it loosens up and becomes creamed. Introduce the powdered sugar a cup at a time, mixing thoroughly. Add in the milk once mixture becomes too thick, then stir in the salt and vanilla. Continue adding milk and sugar until the mixture is the desired thickness.
6. Cut off the tops of the cakes with a large serrated knife to level them. Place the first cake layer on your serving dish, and frost the top with an offset spatula. Repeat until all layers are assembled. Spread the rest of the frosting over the top and sides of the cake evenly.
7. If you're looking for clean slices, make sure to refrigerate the cake for an hour beforehand. Enjoy!

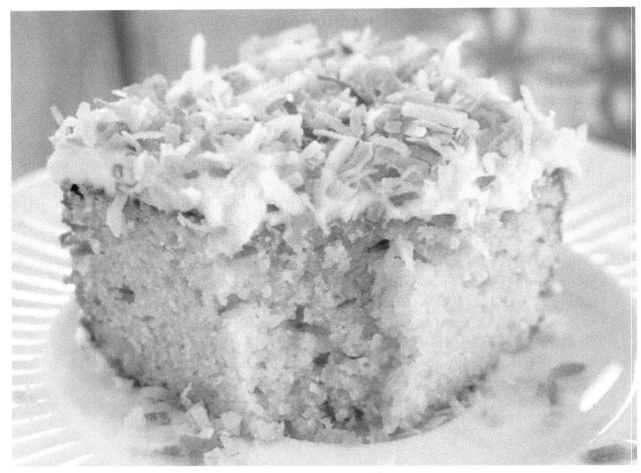

# Coconut Cake

A refreshing hit of coconut, this fluffy cake is perfectly light and satisfying. Easily make it vegan by substituting the butter for, perhaps, coconut oil, and you can leave out the cream cheese and whip the coconut milk separately to make more of a whipped cream frosting.

**Servings: 10 slices**
**Prep Time: 35 minutes**
**Cook Time: 50 minutes**
**Chilling Time: 1 hour**
**Total Time: 2 hours 25 minutes**

## Ingredients:

1 ¾ cups plain or coconut flour

1 ⅔ cups white sugar

1 ½ cups unsalted butter, softened

1 cup coconut milk

5 eggs

2 teaspoons baking powder

½ teaspoon salt

1 ½ teaspoon vanilla

1 ½ teaspoon almond extract

½ cup sweetened shredded coconut

**Frosting**

2 cups powdered sugar

2 cups (16 oz) cream cheese, softened

1 cup unsalted butter, softened

¾ teaspoon vanilla

¼ teaspoon almond extract

1 cup sweetened shredded coconut

## Instructions:

1. Preheat the oven to 355°F and grease two 9 inch round cake pans. Lightly dust with coconut flour.
2. In a medium bowl, whisk together the coconut flour, baking powder, and salt.
3. Using a hand or stand mixer, cream together the butter and sugar until fluffy (3-5 minutes). Beat in the eggs one at a time, then stir in the vanilla and almond extract.
4. Alternate adding in the dry mixture and the milk, starting and ending with the dry mix until incorporated. Using a rubber spatula, fold in the sweetened shredded coconut.
5. Divide the batter evenly into the tins, then bake for 50 minutes, or until they have turned golden brown and a toothpick comes out cleanly from the middle. Cool in the pans until you can handle them, then turn the cakes out onto a wire rack and allow to cool completely, at least an hour.
6. When the cakes are done cooling, make the frosting. With a hand or stand mixer, beat the softened butter and cream cheese until aerated. Mix in the vanilla and almond extract, then add in the powdered sugar ½ cup at a time. If the frosting is too thick, you can loosen it up with coconut milk. Save the shredded coconut for decorating.
7. Either trim off the domes of your cakes or flip them over so you frost the flat bottoms. Sandwich the cakes together with a thick layer of frosting, and spread a thinner layer across the rest of the cake. Press the remaining shredded coconut into the sides and top of the frosted cake, and enjoy!

# Blackout Chocolate Cake

If vanilla isn't your cup of tea, try chocolate! Rich and unctuous, this dark, fudgy cake will satisfy any midnight craving.

**Servings:** 10 slices
**Prep Time:** 15 minutes
**Cook Time:** 35 minutes
**Chilling Time:** 30 minutes
**Total Time:** 1 hour 20 minutes

## Ingredients:

3 cups all-purpose flour
2 cups white sugar
½ cup unsalted butter, softened
1 ½ cup cocoa powder
1 ½ teaspoon baking powder
1 tablespoon baking soda
1 ½ teaspoon salt
4 eggs
1 ½ cups yogurt
2 cups milk
1 tablespoon vanilla

**Frosting**

7 cups powdered sugar
1 ½ cups unsalted butter, softened
1 cup cream cheese, softened
1 ½ cups cocoa powder
¼ cup heavy cream or milk
1 tablespoon vanilla
3 ½ cups semi sweet chocolate chips

# Instructions:

1. Preheat the oven to 350°F and prepare three 9 inch round cake pans with parchment paper and nonstick spray.
2. In a medium bowl, mix together the flour, baking soda and powder, salt, and cocoa powder. Using a hand or stand mixer, cream together the butter and sugar until fluffy, then add in the eggs one at a time and stir in the vanilla. Add in the yogurt. It's okay if the mixture begins to separate, it'll come together.
3. Introduce the dry ingredients into the creamed mixture in three parts, alternating adding about a ½ cup of milk in between. Fold the batter together until just mixed, then divide into the three cake pans.
4. Bake for 35 minutes or until a toothpick comes out cleanly from the center. Allow to cool in the pans until they're able to handle, then cover tightly and place in the freezer for 30 minutes to chill.
5. Once they're ready to use, cream together the butter and cream cheese with a hand or stand mixer and add in a cup of powdered sugar at a time, then add in all of the cocoa powder. Once the mixture becomes too thick, start adding the milk. Continue adding the sugar and milk until desired sweetness and thickness has been achieved. Stir in vanilla.
6. Cut off the domes of your cakes with a large serrated knife, and place the first on your serving dish. Sandwich the cake layers together with a layer of frosting, then frost the outside. Press the chocolate chips into the frosting, slice, and enjoy.

# Angel Food Cake

Arguably one of the fluffiest, lightest substances known to man, this cake is a marvelous vessel for strawberry shortcake filling, whipped cream, or anything you desire.

**Servings: 12 slices**
**Prep Time: 20 minutes**
**Cook Time: 40 minutes**
**Chilling Time: 1 hour**
**Total Time: 2 hours**

# Ingredients:

1 cup cake flour

    1 ½ cups white sugar, with ½ cup divided

    1 ¼ cups egg whites (~9 eggs worth), at room temp

    1 ¼ teaspoons cream of tartar

    ¼ teaspoon salt

    ¼ teaspoon almond extract

    1 teaspoon vanilla

## Instructions:

1. Preheat the oven to 350°F and very lightly grease a loaf pan or a 10 inch bundt pan. Whisk together the egg whites and ½ cup of the sugar in a medium bowl. Make sure your egg whites are warm, at least at room temp. You can set the bowl on the oven to warm them up a bit if your eggs are coming straight from the fridge.
2. Add the cream of tartar and salt to the egg white mixture, and using a hand or stand mixer, beat the egg whites until soft peaks form. Add in the sugar 2 tablespoons at a time and continue whipping until stiff peaks form. Fold in the almond extract and vanilla. Sift in the flour and fold until the batter just comes together.
3. Spoon the mixture carefully into your prepared vessel so as to not deflate the batter. Use a butter knife to cut lines through the batter to prevent air bubbles. Bake on the lowest rack for 35-40 minutes. Once completely baked through and golden brown, immediately flip the pan over onto a wire rack. Cool for at least an hour at room temp.
4. Remove from the pan by running a knife along the edge.

## Carrot Cake

Servings: 12 slices
Prep Time: 20 minutes
Cook Time: 35 minutes
Chilling Time: 1 hour
Total Time: 1 hour 55 minutes

## Ingredients:

3 cups carrots, peeled and grated
2 cups all-purpose flour
1 cup white sugar
¾ cup brown sugar
¾ cup neutral oil
½ cup unsweetened applesauce
4 eggs
2 teaspoons baking powder
1 teaspoon baking soda
½ teaspoon salt
2 teaspoons cinnamon
¼ teaspoon nutmeg
¼ teaspoon ginger
2 teaspoons vanilla
1 cup chopped walnuts (optional)

**Frosting**
4 cups powdered sugar
2 cups (16 oz) cream cheese, softened
1 cup unsalted butter, softened
¾ teaspoon vanilla

# Instructions:

1. Preheat the oven to 350°F and prepare two 9 inch round cake pans with parchment paper cut to the size of the bottom of the tins, and grease with nonstick spray. Dust the pans lightly with flour.
2. Grate your carrots and pat away moisture with paper towels.
3. In a medium bowl, whisk together the flour, baking soda and powder, salt, and spices.
4. Using a hand or stand mixer, beat together the oil, applesauce, sugar, brown sugar, eggs, and vanilla.
5. Add in the dry ingredients in parts, mixing in between. Fold in the grated carrots, then divide the batter between the two pans.
6. Bake for 35-40 minutes, or until a toothpick comes out cleanly from the center.
7. Allow the cakes to cool in the pans until they're able to handle, then flip onto a wire rack. Allow them to cool completely upside-down.
8. Once cooled, whip together the cream cheese and butter with a hand or stand mixer until fluffy. Add in the powdered sugar one cup at a time, then stir in the vanilla. If the frosting is too thick, add in a tablespoon of milk at a time to loosen it up.
9. Place your first cake onto your serving dish and frost the flat side. Sandwich the other cake on top, and frost the top and sides. Push the chopped walnuts into the sides of the cake, if desired.

## Perfect Pound Cake

Simple and perfectly paired with fruit or chocolate, this buttery loaf will be a hit in your house.

**Servings: 8 slices**
**Prep Time: 15 minutes**
**Cook Time: 50 minutes**
**Chilling Time: 0 minutes**
**Total Time: 1 hour 5 minutes**

# Ingredients:

1 ⅓ cups cake flour
¾ cup sugar
3 eggs
13 tablespoons unsalted butter, softened
3 tablespoons milk
¾ teaspoon baking powder
¼ teaspoon salt
1 ½ teaspoons vanilla

## Instructions:

1. Preheat the oven to 350°F and grease a loaf pan with nonstick spray, then dust with flour.
2. In a medium bowl, mix together the eggs, milk, and vanilla. In a separate bowl, mix together the fl0ur, baking powder, and salt. Transfer to a stand mixer or bring out the hand mixer, and blend in the butter and half of the egg mix. Once the flour has been hydrated, beat the dough for one minute, and scrape the sides if necessary. Add in the rest of the egg mixture and continue mixing, trying to incorporate a little air into the batter, but don't overmix.
3. Transfer the batter to the loaf pan and smooth to the edges. Bake for 50 minutes, or until a toothpick comes out cleanly from the center and the top has crisped.
4. Allow the cake to cool in the pan until it's able to handle, then transfer to a wire rack to cool completely.
5. Slice, and enjoy!

# Ultimate New York Cheesecake

Servings: 10 slices
Prep Time: 30 minutes
Cook Time: 1 hour 55 minutes
Chilling Time: 4 hours
Total Time: 6 hours 25 minutes

# Ingredients:

**Graham Cracker Crust**

1 ½ cups graham crackers, crushed

2 tablespoons sugar

5 tablespoons unsalted butter, melted

⅛ teaspoon salt

**Filling**

4 cups cream cheese, softened

2 cups white sugar

6 eggs

½ cup sour cream

3 tablespoons all-purpose flour

4 teaspoons vanilla

1 lemon (1 teaspoon zest, 2 teaspoons juice)

¼ teaspoon salt

## Instructions:

1. Preheat the oven to 375°F and wrap a large piece of aluminum foil around the bottom and sides of a 9 or 10 inch springform pan. If you don't have a springform pan, you can use a round cake pan.
2. In a medium bowl, make the crust. Combine the crushed graham crackers, melted butter, salt, and sugar until a coarse crumb forms. Press the crust into the bottom of the pan and push it up the edges. Bake the crust in the oven for 10 minutes, until crispy, then remove and allow to cool.
3. Reduce the oven to 325°F and boil a kettle of water.
4. Using a hand or stand mixer, beat together the softened cream cheese, sour cream, sugar, and flour until thoroughly mixed. Add in the vanilla, lemon juice and zest, and salt. Add in the eggs one at a time.
5. Place the baked crust in its pan into a large, deep baking dish. Pour the cheesecake mix into the crust and smooth the top, then pour the boiled kettle water into the baking dish, about an inch up the side of the cake. Bake on the lowest rack for 1 hour and 45 minutes. The middle won't be fully set, but shouldn't still be liquidy.
6. Cool the cheesecake in the water bath for about 45 minutes, or until the water is no longer hot. Remove from the roasting pan and wipe off any excess water around the edge.
7. Cover with plastic wrap and cool for at least 4 hours in the fridge, but it's better to leave it overnight.

# Chapter 6: Cupcakes, Muffins, and Cake Pops

If you don't need cake leftovers in your fridge for the next month, consider cupcakes. Perfectly portable and bite size, muffins and cupcakes will get your kids jumping for joy without jeopardizing their health. These little leavened beauties are the perfect opportunity to sneak some good stuff into your kids' snacks. And what kid (or adult) wouldn't want cake pops at their birthday party? They're just so cute!

Take what you've learned in the previous chapter and think smaller, easier, faster.

# Blueberry Muffins

Dare I say it: the perfect muffin. Tart blueberries coated in a moist batter, the only alteration I could suggest is adding a crumble topping made of butter, brown sugar, white sugar, and flour, sprinkled over the tops before they bake. But, they're epic as-is. Follow your heart.

**Servings: 8 muffins**
**Prep Time: 10 minutes**
**Cook Time: 20 minutes**
**Chilling Time: 0 minutes**
**Total Time: 30 minutes**

# Ingredients:

1 ½ cups all-purpose flour
¾ cup white sugar
⅓ cup neutral oil
½ cup milk
1 egg
2 teaspoons baking powder
¼ teaspoon salt
1 ½ teaspoons vanilla
1 cup fresh or frozen blueberries
1 tablespoon turbinado sugar

**Instructions:**

1. Preheat the oven to 400°F and line 8 muffin cups with cupcake liners or parchment paper, or just grease very well with nonstick spray. If you're using a 12 cup muffin tin, pour in a tablespoon of water into the remaining muffin cups so the batch cooks evenly.
2. In a medium bowl, whisk together the flour, sugar, baking powder, and salt. In a smaller bowl, beat the egg and mix with the oil, milk, and vanilla. Create a well in the center of the dry ingredients, and pour the wet mixture in. Gently combine all ingredients, just until there are no more streaks of flour. The batter should be very thick. Coat the blueberries in flour, then fold them in.
3. Spoon the batter evenly into the lined muffin cups. Sprinkle turbinado sugar on the tops of each, and bake for 15-20 minutes, or until a toothpick comes out cleanly.
4. Cool and enjoy!

## Chocolate Chip Muffins

My kids would eat these for breakfast, lunch, and dinner if they could—but they usually only get them packed in their lunches. I might have to recommend making a double batch of these, because they might be gone before you even get a chance to let them cool.

**Servings: 12 muffins**
**Prep Time: 10 minutes**
**Cook Time: 20 minutes**
**Chilling Time: 0 minutes**
**Total Time: 30 minutes**

## Ingredients:

2 cups all-purpose flour
    ½ cup white sugar
    ⅓ cup neutral oil
    ¾ cup milk
    1 egg
    3 teaspoons baking powder
    ½ teaspoon salt
    ¾ cup semi sweet chocolate chips
    3 tablespoons turbinado sugar

## Instructions:

1. Preheat the oven to 400°F and grease the bottoms of 12 muffin cups, or line with cupcake liners.
2. In a medium bowl, whisk together the flour, sugar, baking powder, and salt. In a separate smaller bowl, beat together the egg, oil, and milk. Make a well in the center of the dry ingredients and pour the wet mix in. Mix together the batter until just combined. Fold in the chocolate chips, then spoon the batter into the greased muffin cups. Sprinkle the tops of each muffin with turbinado sugar, then bake for 20-25 minutes or until a toothpick comes out with only moist crumbs attached.
3. Allow to cool slightly before removing from the pans, and enjoy warm!

# Lemon Poppyseed Muffins

Topped with a sweet lemon glaze and packed with fresh lemon flavor, these muffins add the perfect bite of crunch to any breakfast platter. If you wanted to get really fancy, you could spoon out the centers of the cooked muffins and fill them with a ½ tablespoon of lemon curd.

**Servings: 12 muffins**
**Prep Time: 10 minutes**
**Cook Time: 20 minutes**
**Chilling Time: 0 minutes**
**Total Time: 30 minutes**

# Ingredients:

3 cups all-purpose flour
    1 cup white sugar
    8 tablespoons unsalted butter, melted
    1 ½ cups yogurt
    2 eggs
    1 teaspoon baking powder
    ½ tablespoon baking soda
    ½ teaspoon salt
    2 tablespoons poppy seeds
    2 lemons (2 tablespoons juice, 1 ½ tablespoon zest)

**Glaze**
¼ cup white sugar
¼ cup lemon juice
1 tablespoon turbinado sugar

## Instructions:

1. Preheat the oven to 375°F and grease a 12 cup muffin tin with nonstick spray, or line with cupcake liners.
2. In a large bowl, whisk together the flour, sugar, baking powder and soda, salt, and poppy seeds together. In a separate bowl, beat together the eggs, yogurt, melted butter, lemon zest and juice, until just combined. Create a well in the center of the dry mixture, then pour in the wet ingredients, and fold together until just combined. Spoon the batter into the prepared muffin cups and bake for 20-25 minutes until a toothpick comes out cleanly.
3. While they bake, combine the sugar and lemon juice in a small saucepan and simmer over medium heat for 3-5 minutes, until it thickens slightly.
4. Allow the muffins to cool, then brush the tops with the lemon glaze. Finally, sprinkle turbinado sugar on the tops of the muffins, and enjoy.

# Maple Chai Pumpkin Muffins

In the mood for the taste of autumn? These moist, spicy muffins will make it feel like the leaves are turning any time of the year.

**Servings: 12 muffins**
**Prep Time: 10 minutes**
**Cook Time: 20 minutes**
**Chilling Time: 0 minutes**
**Total Time: 30 minutes**

# Ingredients:

1 cup all-purpose flour
¾ cup whole wheat flour
1 cup canned pumpkin puree
2 eggs
⅓ cup coconut oil, melted
½ cup maple syrup
¼ cup milk
1 teaspoon baking soda
1 teaspoon cinnamon
½ teaspoon cardamom
⅛ teaspoon nutmeg
⅛ teaspoon cloves
½ teaspoon salt
1 teaspoon vanilla
2 tablespoons pepitas

## Instructions:

1. Preheat the oven to 325°F and grease a 12 cup muffin tin with nonstick spray.
2. In a large bowl, whisk together the whole wheat and all purpose flour, baking soda, salt, and spices. In a separate medium bowl, whisk together the eggs, pumpkin puree, maple syrup, coconut oil, milk, and vanilla. Fold in the wet ingredients to the dry until just combined. Divide evenly between the muffin cups, then top with pepitas.
3. Bake for 20-25 minutes, or until a toothpick comes out cleanly. Cool for 5 minutes before enjoying.

# Black Forest Cupcakes

If you're searching for a rich, decadent dessert for an anniversary or special occasion, look no further. Chocolate and cherries pair expertly together, layered under a light whipped topping.

**Servings: 12 cupcakes**
**Prep Time: 10 minutes**
**Cook Time: 20 minutes**
**Chilling Time: 20 minutes**
**Total Time: 50 minutes**

## Ingredients:

¾ cup bread flour

¾ cup white sugar

⅓ cup cocoa powder

¼ cup + 2 tablespoons neutral oil

2 eggs

½ teaspoon baking soda

½ teaspoon salt

2 teaspoon vinegar

1 ½ teaspoon vanilla

¼ cup bittersweet chocolate, chopped

¾ cup hot water

**Topping and Filling**

1 ½ cup heavy cream

¼ cup white sugar

1 ¼ cup canned cherry pie filling

2 tablespoons chocolate sprinkles or chopped chocolate

# Instructions:

1. Preheat the oven to 350°F and line 12 muffin cups with cupcake liners or grease well with nonstick spray. In a heat-proof bowl, combine the chopped chocolate, cocoa powder, and hot water. Whisk vigorously until all lumps are gone. Cover with plastic wrap and transfer to the refrigerator to cool for 20 minutes. Stir after about 10 minutes.
2. In a medium bowl, combine the cake flour, sugar, baking soda, and salt. In a smaller bowl, whisk together the oil, eggs, vanilla, and vinegar. Pour the chilled chocolate mixture into the wet ingredients, and stir thoroughly. Add the flour mixture in three parts, stirring in between additions. Mix until just combined.
3. Spoon the mixture into the prepared muffin tin and bake for 18-20 minutes, or until a toothpick comes out cleanly from the centers.
4. Allow to cool in the pan until it's able to handle and then cool the cupcakes on a wire rack completely.
5. Using a paring knife, cut and scoop a hole out of the centers of the cupcakes, and spoon in about a little more than a tablespoon of cherry filling to each.
6. Using a hand or stand mixer, whip the heavy cream until stiff peaks form, gradually adding in the sugar as you go. Pipe or spread the whipped cream over each cupcake and garnish with sprinkles or chopped chocolate, and enjoy!

## Strawberry Cake Pops

If you want to make this process a little easier for yourself, you can use a can of store bought frosting to mix with the crumbled cake, just make sure it's softened. You can also bake the cake the day before so it's ready to go when you need it.

**Servings:** 45 cake pops
**Prep Time:** 1 hour
**Cook Time:** 35 minutes
**Chilling Time:** 2 hours
**Total Time:** 3 hours 35 minutes

# Ingredients:

**Cake**

    1 ¾ cup all-purpose flour

    1 cup white sugar

    8 tablespoons unsalted butter, softened

    3 egg whites

    ¼ cup yogurt

    ⅓ cup milk

    1 teaspoon baking powder

    ¼ teaspoon baking soda

    ¼ teaspoon salt

    1 ½ teaspoon vanilla

    ¼ cup strawberry puree

    red food coloring, optional

**Frosting**

    1 ¾ cup powdered sugar

    ½ cup unsalted butter, softened

    3-4 tablespoons milk

    1 teaspoon vanilla

    ½ cup freeze dried strawberries, crushed

**Coating**

    5 cups white chocolate chips

    2 tablespoons neutral oil

    2 tablespoons sprinkles or freeze dried strawberries

## Instructions:

1. Preheat the oven to 350°F and grease a 9 inch round cake pan with nonstick spray.
2. In a medium bowl, whisk together the flour, baking soda and powder, and salt. Using a hand or stand mixer, cream together the butter and sugar until fluffy. Add in the egg, greek yogurt, and vanilla and beat until smooth. Add in the flour mixture in three parts, adding in a couple tablespoons of milk in between. Fold in the strawberry puree and a couple drops of food coloring, if desired. Be careful not to overmix.
3. Transfer the batter to the prepared cake pan, and bake for 30-35 minutes, or until a toothpick comes out cleanly from the center. If your cake is drowning too fast, cover with tin foil and continue baking.
4. Allow the cake to cool in its pan until it's able to handle, then cover and chill in the freezer for 30 minutes.
5. While the cake is chilling, whip the butter for the frosting with a hand or stand mixer until fluffy and lighter in color, and incorporate about a cup of powdered sugar at a time until it's all combined. Stream in a tablespoon of milk at a time until desired thickness is reached. Stir in the vanilla and crushed freeze dried strawberries, and keep at room temperature.
6. Once the cake is cooled, remove it from the pan and crumble into a medium bowl using your hands. Stir in the frosting, either with a spatula, or a hand or stand mixer on low speed.
7. Take about a tablespoon of the dough and roll into a ball. Place the balls on a baking sheet, cover, and allow them to chill in the freezer for 30 minutes.
8. Melt the white chocolate chips with the oil in the microwave or use a double boiler. Pour the melted chocolate coating into a large liquid measuring cup or a wide glass.
9. Dip the tips of lollipop sticks or skewers into the chocolate, then position the cake balls on each of them. I recommend taking 5 out of the freezer at a time to dip. Once the cake balls are placed on the sticks, dip them fully in the candy coating, and garnish with sprinkles or crushed freeze-dried strawberries.
10. Place your cake pops upright to dry, by poking holes in a cardboard box or piece of styrofoam. Allow to cool at room temperature, about an hour until they're completely set.
11. Store in the fridge if you have leftovers.

# Chapter 7: Breads and Savory Bakes

There is no greater peace than conquering a tempermental yeast bread and allowing your home to be filled with the warm aroma of freshly baked bread. Whether your dinner needs a carb, or the table needs an appetizer, this section will ease you into breadmaking.

## Potato Dinner Rolls

Servings: 16-20 rolls
 Prep Time: 20 minutes
 Cook Time: 25 minutes
 Rising Time: 2 hours
 Total Time: 2 hours 45 minutes

# Ingredients:

1 cup boiled and mashed potatoes

4 ½-5 cups all-purpose flour

⅓ cup + 1 teaspoon white sugar, divided

6 tablespoons unsalted butter, melted

¼ cup milk

2 eggs

2 ¼ teaspoon (1 package) active dry yeast

½ cup room temperature water

2 teaspoons salt

2 ½ teaspoons rosemary

**Topping**

¼ cup unsalted butter, softened

2 tablespoons honey

½ teaspoon salt

## Instructions:

1. In a large bowl, combine the yeast, water, and 1 tablespoon of sugar. Allow to sit for 5 minutes, or until the yeast starts to bubble.
2. Add in the rest of the sugar, mashed potatoes, eggs, milk, butter, rosemary and salt and fold together with a rubber spatula. Add in a cup of flour at a time until a loose dough forms. Transfer the dough to a heavily floured surface and knead the dough for 5-8 minutes by pushing the dough over itself, roating, and repeating. Do this until the dough is smooth and no longer sticky. Add more flour if necessary. Spray the bowl you were using with nonstick spray and return the dough to it. Cover with plastic wrap or a clean kitchen towel and allow it to sit in a warm spot for 1 hour.
3. Grease a 9x13 baking dish with nonstick spray. Transfer to a floured surface and cut the dough into 16-20 pieces, depending on how big you want your rolls. Keep in mind that they will prove again and get bigger. Roll the pieces into balls and place seam-side down into the prepared baking dish. Cover with plastic wrap or a kitchen towel and allow to sit for 1 more hour, or until doubled in size. Preheat the oven to 350°F about 15 minutes before you're ready to bake.
4. Bake for 20-25 minutes, or until the tops have turned golden brown and have firmed up. You can crack a roll open when you think they're done to check for undercooked dough.
5. In a small bowl, whisk together the softened butter with the honey, then brush on top of the baked rolls with a pastry brush. Sprinkle with flaky salt, if desired.

## Classic White Bread

Servings: 16-20 rolls
 Prep Time: 20 minutes
 Cook Time: 40 minutes
 Rising Time: 1 hour 30 minutes
 Total Time: 2 hours 30 minutes

## Ingredients:

5-6 cups all-purpose flour
- ½ cup white sugar, with 1 tablespoon divided
- ¼ cup neutral oil
- 1 ½ teaspoons salt
- 2 cups warm water
- 1 ½ tablespoons active dry yeast

# Instructions:

1. In a large bowl, dissolve 1 tablespoon of sugar into the warm water, then whisk in the yeast. Allow to sit at room temperature for 5 minutes, until foamy.
2. Mix in the rest of the sugar, oil, and salt into the bowl, then mix in 1 cup of flour at a time until a loose, sticky dough forms.
3. Turn out the dough onto a well floured surface and knead for 5-7 minutes. Grease the bowl very well with nonstick spray and return the dough, then cover with plastic wrap or a kitchen towel and allow to sit at room temperature for 1 hour.
4. Grease two loaf pans with nonstick spray. Once the dough has proved, punch down the dough and knead for an additional minute, then divide in half, shape the loaves and place them seam side down in the loaf pans. Allow to rise for 30 more minutes in the pans. The dough should have risen about an inch above the lip of the pans. Preheat the oven to 350°F.
5. Bake for 35-40 minutes, allow to cool, slice, and enjoy!

## Rosemary Focaccia

Servings: 8-12 rolls
 Prep Time: 20 minutes
 Cook Time: 20 minutes
 Rising Time: 1 hour 20 minutes
 Total Time: 2 hours

## Ingredients:

3 ½ cups all-purpose flour
    ¼ cup high quality olive oil
    1 ⅓ cup warm water
    2 teaspoons white sugar
    1 ½ teaspoon (1 package) active dry yeast
    2 teaspoons salt
    2 sprigs fresh rosemary, minced

## Instructions:

1. In a large bowl or in the bowl of a stand mixer, add warm water and sugar, then stir to combine. Sprinkle the yeast on top, lightly stir together, then allow to sit for 5-1o minutes. Once the yeast is foamy, add in the oil, salt, and stir in the flour. Either knead with the stand mixer attachment or turn out onto a floured surface and knead by hand for 5 minutes. Add more flour if it's too sticky.
2. Grease a mixing bowl and form the dough into a ball, placing it in the bowl and covering with plastic wrap or a kitchen towel. Allow to proof for 1 hour, until doubled in size.
3. Grease a 9x13 inch baking dish and shape your dough in the pan. It might not reach all the way to the edges, so cover and allow it to proof for an additional 2o minutes. Then, spread to the edges of the dish, and poke deep holes all the way into the dough. Drizzle a good amount of olive oil all over the dough and in the crevices. Sprinkle with minced rosemary and salt, and bake for 20 minutes, until golden and baked through.

## Chapter 8: In Conclusion

Baking is a gift. To yourself, to your loved ones, and I hope that after perusing this book, you have been inspired to get in the kitchen, build your skills, and bring love into your home.

You now have an enormous cache of recipes in your back pocket, and they can be molded to create any flavor or texture that you desire. Now is the time to experiment! Or, keep making the recipes that comfort you and make your heart warm. Whatever you do, keep baking. Keep creating. The benefits are limitless, and you will never regret finding a stash of cookies in your freezer. Show up to the bake sales, the soccer games, the birthday parties, and you might even inspire another mom to put more effort into their homemaking.

I hope that this book has taught you patience, and passed down the blessed knowledge that my grandmother passed to my mom, and to me, and to my children. And, now, to all of you.

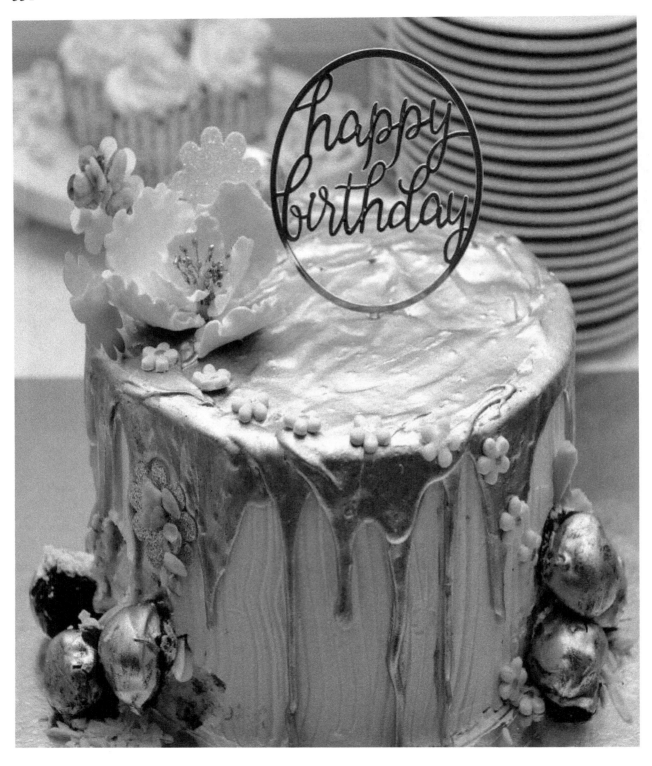

# Glossary

**Aerate:** to incorporate air into a substance

**Batter:** a mixture that has enough liquid in it to be poured, usually made of flour, eggs, and milk.

**Beat:** the action of vigorously mixing ingredients together using some sort of tool until completely incorporated.

**Blind Bake:** pre-baking a crust or dessert component in the oven, usually weighed down with pie weights or dried beans/rice so the pastry doesn't puff.

**Cream:** the action of combining butter and sugar until light and fluffy.

**Double Boiler:** a heatsafe bowl placed atop a pot with a very small amount of simmering water; a method of melting chocolate.

**Fold:** to gently incorporate an ingredient by cutting through the batter and folding through, rotating the bowl.

**Grease:** to completely coat a vessel with a fat (usually nonstick spray).

**Knead:** massage and work a dough with your hands.

**Proof:** allow a yeasted dough to sit in a warm place for an amount of time so the dough can rise.

**Soft Peaks:** to whip a substance to a point where it can hold its shape, but when lifted up, the peak will fold over itself.

**Stiff Peaks:** to whip a substance to a point where it can hold its shape and when lifted up, the peak will stay completely upright.

**Whip:** using a whisk or electric mixer to aerate a substance.

# References

*5 educational benefits of home baking with your kids.* (2021 January 19). Cakes by Robin. https://www.cakesbyrobin.co.uk/blog/5-educational-benefits-of-home-baking-with-your-kids/[1]

*9 essential ingredients every Baker needs.* (2016 April 26). Allrecipes. https://www.allrecipes.com/article/essential-baking-ingredients/

Allen, L. (2019 August 10). *Peach cobbler.* Tastes Better From Scratch. https://tastesbetterfromscratch.com/peach-cobbler/

*Apple crumble bars.* (2020 November 13). RecipeTin Eats. https://www.recipetineats.com/apple-crumble-bars/

*Bakery style lemon poppy seed muffins.* (2020 September 29). A Kitchen Addiction. https://www.a-kitchen-addiction.com/bakery-style-lemon-poppy-seed-muffins/

*Banana cream pie I.* (1998 May 4). Allrecipes. https://www.allrecipes.com/recipe/12151/banana-cream-pie-i/

Bangalore Mirror Bureau. (2020, March 10). *85% of millennial working mothers don't cook at home: Survey.* https://bangaloremirror.indiatimes.com/opinion/you/85-of-millennial-working-mothers-dont-cook-at-home-survey/articleshow/74559205.cms

Beck, A. (2018 November 20). *These 21 baking tools are absolutely essential.* Better Homes & Gardens. https://www.bhg.com/recipes/how-to/bake/essential-baking-tools/

*Best angel food cake.* (2022 April 22). Taste of Home. https://www.tasteofhome.com/recipes/best-angel-food-cake/

*Best carrot cake recipe.* (2020 April 13). Cooking Classy. https://www.cookingclassy.com/best-ever-carrot-cake/

*Best ever blueberry cobbler.* (1999 May 29). Allrecipes. https://www.allrecipes.com/recipe/15373/best-ever-blueberry-cobbler/

*The best lemon bars.* (1997 October 18). Allrecipes. https://www.allrecipes.com/recipe/10294/the-best-lemon-bars/

---

1. https://www.cakesbyrobin.co.uk/blog/5-educational-benefits-of-home-baking-with-your-kids/

*The best vanilla cake I've ever had.* (2021 June 30). Sally's Baking Addiction. https://sallysbakingaddiction.com/vanilla-cake/

Billboard Staff. (2019 December 12). *Taylor Swift will receive first-ever woman of the decade honor at billboard's women in music.* Billboard. https://www.billboard.com/music/pop/taylor-swift-first-ever-woman-of-the-decade-award-8543996/

Bitans, E. R. (n.d.). *Plate of sliced bread.* Pexels. https://www.pexels.com/photo/plate-of-sliced-breads-1448665/

*Black forest cupcakes.* (2020 March 7). Cooking Classy. https://www.cookingclassy.com/black-forest-cupcakes/

*Blackberry Pear Pie.* (2021 April 13). Oregon Raspberries & Blackberries. https://oregon-berries.com/recipe/blackberry-pear-pie/

*Blackout chocolate cake.* (2021 June 4). Pinch of Yum. https://pinchofyum.com/blackout-chocolate-cake

Bonisteel, S. (n.d.). *Shoofly pie recipe.* NYT Cooking. https://cooking.nytimes.com/recipes/1017018-shoofly-pie

Caramelle bakery. (n.d.). *Sliced key lime pie on white ceramic plate.* Pexals. https://www.pexels.com/photo/sliced-key-lime-pie-on-white-ceramic-plate-4529015/

*Chocolate chip muffins.* (1998 March 18). Allrecipes. https://www.allrecipes.com/recipe/7906/chocolate-chip-muffins/

*Classic peanut butter cookies.* (1997 December 31). Allrecipes. https://www.allrecipes.com/recipe/10275/classic-peanut-butter-cookies/

*Coconut cake.* (2015 September 4). Food Network UK. https://foodnetwork.co.uk/recipes/coconut-cake/?utm_source=foodnetwork.com&utm_medium=domestic

Dady, J. (2022 March 21). *Cornflake cakes.* GoodtoKnow. https://www.goodto.com/recipes/honey-joys-cornflakes-cakes

*Dinner potato rolls.* (2016 November 4). Simply Recipes. https://www.simplyrecipes.com/recipes/potato_dinner_rolls/

*Double ginger cookies.* (2014 November 26). Ricardocuisine. https://www.ricardocuisine.com/en/recipes/6556-double-ginger-cookies

*Dulce de leche mocha cupcakes*. (2021 June 8). Pies and Tacos. https://www.piesandtacos.com/dulce-de-leche-mocha-cupcakes/

*Easy chocolate avocado pudding*. (2022 January 13). Making Thyme for Health. https://www.makingthymeforhealth.com/easy-superfood-chocolate-pudding/

*Easy fudgy brownies from scratch*. (2020 October 1). Inspired Taste. https://www.inspiredtaste.net/24412/cocoa-brownies-recipe/

*Easy homemade bread recipe*. (2020 July 30). Butter with a Side of Bread. https://butterwithasideofbread.com/homemade-bread/

*Easy homemade cherry pie*. (2017 July 28). Inspired Taste. https://www.inspiredtaste.net/22872/easy-cherry-pie-recipe/

Fortin, D. (2021 October 19). *American apple pie*. Del's cooking twist. https://www.delscookingtwist.com/american-apple-pie/

*Frosted banana bars*. (2022 April 22). Taste of Home. https://www.tasteofhome.com/recipes/frosted-banana-bars/

Fuentes, L. (2022 March 14). *Chocolate coconut Paleo energy balls*. https://www.laurafuentes.com/healthy-coconut-brownie-energy-bites/

Gerard, T. (2020 September 4). *Salted maple Apple Tarte tatin*. Half Baked Harvest. https://www.halfbakedharvest.com/salted-maple-apple-tarte-tatin-with-vanilla-cream-toasted-pumpkin-seeds/

*Grandma's lemon meringue pie*. (1999 May 5). Allrecipes. https://www.allrecipes.com/recipe/15093/grandmas-lemon-meringue-pie/

Gurbani, A. (2016 September 14). *Frangipane tart with figs and plums*. The Feedfeed. https://thefeedfeed.com/thejamlab/frangipane-tart-with-figs-and-plums

Hamilton, K. (2022 April 4). *Strawberry cake pops*. Bake & Bacon. https://www.bakeandbacon.com/strawberry-cake-pops/#ingredients-needed

*Hand mixer vs. stand mixer: What's the difference?* (2020 December 1). KitchenAid. https://www.kitchenaid.com/pinch-of-help/countertop-appliances/stand-mixer-vs-hand-mixer.html

Haney, E. (n.d.). *Brown cookies with melted chocolate on top*. Pexels. https://www.pexels.com/photo/brown-cookies-with-melted-chocolate-on-top-90614/

*Hazelnut sandwich cookies recipe*. (2013 December 6). Food & Wine. https://www.foodandwine.com/recipes/hazelnut-sandwich-cookies

*Healthy carrot muffins*. (2020 October 25). Cookie and Kate. https://cookieandkate.com/healthy-carrot-muffins-recipe/

Hill, M. (2020 October 25). *Mini quiche 4 ways*. Culinary Hill. https://www.culinaryhill.com/mini-quiche-4-ways/

Hobbes, S. (n.d.). *Muesli Bars*. Taste.com.au. https://www.taste.com.au/recipes/muesli-bars/114e2735-8223-40f3-94be-394c7858809e

Kalmy. (n.d.). *Easy Banana Cake*. Australia's Best Recipes. https://www.bestrecipes.com.au/recipes/easy-banana-cake-recipe/i1i5a4bj

Kanell, J. (2020 October 16). *Buckeye recipe*. Preppy Kitchen. https://preppykitchen.com/buckeyes/

Kanell, J. (2021 March 19). *Banoffee pie*. Preppy Kitchen. https://preppykitchen.com/banoffee-pie/

Kanell, J. (2021 April 16). *Black and white cookies*. Preppy Kitchen. https://preppykitchen.com/black-and-white-cookies/[2]

Kasumi Loffler. (n.d.). *Close up photo of pumpkin pie with whipped cream*. Pexels. https://www.pexels.com/photo/close-up-photo-of-pumpkin-pie-with-whipped-cream-3535390/

*Key lime pie*. (2022 April 29). Once Upon a Chef. https://www.onceuponachef.com/recipes/key-lime-pie.html

Kidspot Kitchen. (n.d.). *Sweet potato, spinach, and feta muffins*. Kidspot.com.au. https://www.kidspot.com.au/kitchen/recipes/sweet-potato-spinach-feta-muffins-recipe/47kl3ejf

Lane, C. (2020 November 8). *Red velvet cake pops*. Dessert for Two. https://www.dessertfortwo.com/red-velvet-truffles/

Lazar, A. (n.d.). *Sliced strawberries on white textile*. Pexels. https://www.pexels.com/photo/food-sugar-breakfast-dessert-8485975/

---

2. https://www.citefast.com/%E2%80%8B%E2%80%8Bhttps://preppykitchen.com/black-and-white-cookies/

Lee, D. (n.d.). *Cheese bacon puffs*. Australia's Best Recipes. https://www.bestrecipes.com.au/recipes/cheese-bacon-puffs-recipe/do2brmfp

*Lemon tart*. (2021 June 19). RecipeTin Eats. https://www.recipetineats.com/lemon-tart/

Little, S. (2021 March 4). *Chocolate chess pie*. Southern Bite. https://southernbite.com/chocolate-chess-pie/

Magni, O. (n.d.). *Baked pie*. Pexels. https://www.pexels.com/photo/baked-pie-989704/

*Maple-chai pumpkin muffins*. (n.d.). Punchfork. https://www.punchfork.com/recipe/Maple-Chai-Pumpkin-Muffins-Taste-of-Home[3]

Mettler, L. (2021 July 28). *Spice organization 101: How to organize & store spices in your kitchen*. OXO Good Tips. https://www.oxo.com/blog/cleaning-and-organizing/how-to-store-organize-spices/

Mike. (n.d.). *Dessert served on brown wooden tray*. Pexels. https://www.pexels.com/photo/dessert-served-on-brown-wooden-tray-109836/

*Millionaire's shortbread*. (2021 April 5). Once Upon a Chef. https://www.onceuponachef.com/recipes/chocolate-caramel-shortbread-squares-a-k-a-millionaires-shortbread.html

Monson, N. (2022 January 13). *5 ingredient homemade granola*. Super Healthy Kids. https://www.superhealthykids.com/homemade-granola-only-5-ingredients/

Monson, N. (2022 February 9). *Homemade banana pudding recipe*. Super Healthy Kids. https://www.superhealthykids.com/pot-of-golden-banana-pudding-recipe/

Muchly, M. (2021 November 19). *"baking is done out of love, to share with family and friends, to see them smile."*. My Own Little World. Retrieved May 7, 2022, from https://myownlittleworld.net/2021/11/16/baking-is-done-out-of-love-to-share-with-family-and-friends-to-see-them-smile/

*My favorite pecan pie recipe*. (2022 February 3). Sally's Baking Addiction. https://sallysbakingaddiction.com/my-favorite-pecan-pie-recipe/

*No bake energy bites*. (2020 March 29). Gimme Some Oven. https://www.gimmesomeoven.com/no-bake-energy-bites/

*Oatmeal Cranberry Almond Bars*. (2019 December 18). Health.com. https://www.health.com/food/the-oatmeal-cranberry-almond-bars-that-work-for-breakfast-a-snack-or-dessert

---

3. https://www.citefast.com/%E2%80%8B%E2%80%8Bhttps://www.punchfork.com/recipe/Maple-Chai-Pumpkin-Muffins-Taste-of-Home

*Oatmeal raisin cookies (soft & chewy)*. (2021 February 28). Live Well Bake Often. https://www.livewellbakeoften.com/soft-chewy-oatmeal-raisin-cookies/

Ozug, J. (2019 September 19). *Fruit roll UPS - How to make homemade fruit roll UPS*. Fifteen Spatulas. https://www.fifteenspatulas.com/homemade-strawberry-fruit-rollups/

Palanjian, A. (2022 April 25). *So good pizza muffins (with veggies!)*. Yummy Toddler Food. https://www.yummytoddlerfood.com/pizza-muffins/

*Pear Custard bars*. (2021 September 29). Taste of Home. https://www.tasteofhome.com/recipes/pear-custard-bars/

*Perfect pound cake*. (2021 December 20). Once Upon a Chef. https://www.onceuponachef.com/recipes/perfect-pound-cake.html

*Perfect pumpkin pie*. (2000 November 1). Allrecipes. https://www.allrecipes.com/recipe/23439/perfect-pumpkin-pie/

Pflug, S. (n.d.). *Seasoned chickpeas*. Burst.shopify. https://burst.shopify.com/photos/close-up-of-seasoned-chickpeas?q=chickpeas

Pillsbury Kitchens. (2021 May 6). *Kentucky Chocolate and Walnut Pie*. Pillsbury.com. https://www.pillsbury.com/recipes/kentucky-chocolate-and-walnut-pie/58a2f52d-2030-4713-a23d-65f85025f8a

Pillsbury Kitchens. (n.d.). *Cookie pizza*. Pillsbury.com. https://www.pillsbury.com/recipes/cookie-pizza/70d94253-eb3d-47f9-9845-73ea580eecd6

*Quick and easy blueberry muffins*. (2021 August 27). Inspired Taste. https://www.inspiredtaste.net/18982/our-favorite-easy-blueberry-muffin-recipe

*Reasons to make homemade cookies*. (n.d.). Best Ever Cookie Collection. https://www.best-ever-cookie-collection.com/reasons-to-make-homemade-cookies.html

*Red velvet chocolate chip cookies*. (2022 February 8). Sally's Baking Addiction. https://sallysbakingaddiction.com/red-velvet-chocolate-chip-cookies/

Rielly, R. (2017 July 27). *Why baking makes you feel happier*. Spoon University. https://spoonuniversity.com/lifestyle/feel-happier-through-baking

Rivers, A. (2021 July 8). *The easiest fresh strawberry pie*. The Recipe Critic. https://therecipecritic.com/strawberry-pie/

*Rocky road pie*. (2020 May 18). Recipe Girl. https://www.recipegirl.com/rocky-road-pie/

*Rosemary focaccia bread recipe*. (2020 March 31). Gimme Some Oven. https://www.gimmesomeoven.com/rosemary-focaccia-bread/

Ryder, A. (2021 August 20). *Cheesy zucchini muffins*. Simply Delicious. https://simply-delicious-food.com/cheesy-zucchini-muffins/

*Salted chocolate tart*. (2015 September 4). Food Network UK. https://foodnetwork.co.uk/recipes/chocolate-tart/?utm_source=foodnetwork.com&utm_medium=domestic

*Sausage rolls*. (2020 October 27). RecipeTin Eats. https://www.recipetineats.com/special-pork-fennel-sausage-rolls/

Scheuer, C. (2019 July 22). *Peanut butter and jelly blondies*. The Café Sucre Farine. https://thecafesucrefarine.com/peanut-butter-and-jelly-blondies/

Segal, J. (2021 July 5). *Coconut macaroons*. Once Upon a Chef. https://www.onceuponachef.com/recipes/coconut-macaroons.html

Segal, J. (2021 April 5). *New York-style cheesecake*. Once Upon a Chef. https://www.onceuponachef.com/recipes/new-york-style-cheesecake.html

Seneviratne, S. (n.d.). *Mississippi Mud Pie*. NYT Cooking. https://cooking.nytimes.com/recipes/1018722-mississippi-mud-pie[4]

Sergienko, O. (n.d.). *Slice of cake with raspberry topping*. Pexels. https://www.pexels.com/photo/slice-of-cake-with-raspberry-topping-3323686/

Shoemaker, S., & McGrane, K. (2022 March 15). *Vanilla essence vs. extract: What's the difference?* Healthline. https://www.healthline.com/nutrition/vanilla-extract-vs-essence

Shugarman, A. (2021 February 8). *Perfect rice Krispie treats recipe*. Shugary Sweets. https://www.shugarysweets.com/perfect-rice-krispie-treats/

*Soft & thick snickerdoodles*. (2021 January 21). Sally's Baking Addiction. https://sallysbakingaddiction.com/soft-thick-snickerdoodles-in-20-minutes/

Spencer, T. (2022 April 16). *Mini british bakewell tarts (almond & jam tarts)*. Scotch & Scones. https://www.scotchandscones.com/bakewell-tarts/

---

[4]. https://www.citefast.com/%E2%80%8B%E2%80%8Bhttps://cooking.nytimes.com/recipes/1018722-mississippi-mud-pie

Staff, T. (2022 February 4). *Italian rainbow cookie recipe*. TastingTable. https://www.tastingtable.com/686065/italian-rainbow-cookie-recipe/

Stafford, G. (2021 June 11). *Homemade graham crackers*. Gemma's Bigger Bolder Baking. https://www.biggerbolderbaking.com/homemade-graham-crackers/[5]

Stone, R. (2021 October 25). *Southern sweet potato pie recipe*. Add a Pinch. https://addapinch.com/southern-sweet-potato-pie-recipe/

*Store cupboard essentials - my list and tips*. (2020 March 16). You Say Tomato. https://www.yousaytomatocooking.com/tips/my-storecupboard-essentials/

*Sugar cream pie*. (2022 April 25). Taste of Home. https://www.tasteofhome.com/recipes/sugar-cream-pie/

Sun, K. (n.d.). *Choc chip and oat slice*. Taste.com.au. https://www.taste.com.au/recipes/choc-chip-oat-slice/017856d2-fc17-4aae-b771-8ac2e6d2f8cd

Szewczyk, J. (2020 April 23). *How To Make the Absolute Best Strawberry Rhubarb Pie*. The Kitchn. https://www.thekitchn.com/strawberry-rhubarb-pie-recipe-23010122

Tankilevitch, P. (n.d.). *Close-up photo of sliced chocolate cake*. Pexels. https://www.pexels.com/photo/close-up-photo-of-sliced-chocolate-cake-4110008/

*Taylor Swift, Khloe Kardashian and more stars who love to bake*. (2021 December 5). Us Weekly. https://www.usmagazine.com/food/pictures/taylor-swift-khloe-kardashian-more-stars-who-love-to-bake-pics/

*Top 10 tips for the beginner Baker for less stress!* (2016 June 19). JUNIPER CAKERY. https://www.junipercakery.co.uk/blog/top-10-tips-for-the-beginner-baker/

*The best american bakery-style chocolate chip cookies*. (2019 October 22). Living on Cookies. https://livingoncookies.com/the-best-american-bakery-style-chocolate-chip-cookies/

White, C. (2020 November 1). *Healthy gummies*. Chelsweets. https://chelsweets.com/healthy-gummy-bears/

Whiteford, A. (2021 March 22). *Baked chickpeas*. Healthy Little Foodies. https://www.healthylittlefoodies.com/curried-baked-chickpeas/

*Whoopie pies*. (2020 February 1). Cooking Classy. https://www.cookingclassy.com/whoopie-pies/

---

5. https://www.citefast.com/%E2%80%8B%E2%80%8Bhttps://www.biggerbolderbaking.com/homemade-graham-crackers/

WikimediaImages. (n.d.). *Kitchen dough blender*. Pixabay. https://pixabay.com/images/id-2202232/

Williams, L. (2021 March 2). *Ham and pineapple pinwheels*. Stay at Home Mum. https://www.stayathomemum.com.au/recipes/ham-and-pineapple-pinwheels/

Younkin, M. (2021 May 27). *Pineapple coconut bars*. Barefeet in the Kitchen. https://barefeetinthekitchen.com/pineapple-coconut-bars-recipe/

# Don't miss out!

Visit the website below and you can sign up to receive emails whenever Maleb Braine publishes a new book. There's no charge and no obligation.

https://books2read.com/r/B-A-WOXU-XGABC

**BOOKS2READ**

Connecting independent readers to independent writers.

# Also by Maleb Braine

**Everyday cookbook series.**
French cookbook for everyday use.
Italian Cookbook for everyday use.
Bread baking cookbook you need every day
A baking cookbook you need Every Day

CPSIA information can be obtained
at www.ICGtesting.com
Printed in the USA
BVHW011520211022
649988BV00002B/9